Love & Hugs-
Maurice Mouse
+
Tara

to Mickey
Best wishes
Michael

Scottsdale
a portrait in color

Michel F. Sarda

The Past and the Promise
An introduction
by
Mayor Herbert R. Drinkwater

❦

The First 100 Years
A brief history
by
Lois McFarland

❦

Contributing Photographers

Brad Armstrong
Alan Benoit
Michael Mertz
Peter Mortimer
Sonny Ness
Bill Timmerman

Bridgewood Press
Phoenix, Arizona

Acknowledgements

To Mayor Herb Drinkwater, for his friendly personal support.

For contributing personal tributes to this book: to Russ Allen, Sam Kathryn Campana, Morton Fleischer, Misdee Furey, Richard Hill, Howard Keim, Meredith Harless Williams, Dennis Lyon, Florence Nelson, Bruce Pfeiffer, Stephanie Roberts, Bill Schrader, Susan Bitter Smith, Mae Sue Talley, Bill Walton.

For contributing their superb photographic work: Brad Armstrong, Alan Benoit, Michael Mertz, Peter Mortimer, Sonny Ness, Bill Timmerman.

For their support:

To Catherine Day, John Little, Rich Wetzel, Sally Weyers, Lisa Honebrink and the staff of the City of Scottsdale,

To Philip L. Carlson, executive director, Rachel Sacco, Anne Wendell, the Board of Directors and the staff of the Scottsdale Chamber of Commerce.

To the Scottsdale Historical Society, to Darlene Petersen and to JoAnn Handley for her time and expertise.

To Chuck Pettit, publisher, Lois McFarland, Darlene Shaw, Steve Wilson and the staff of the Scottsdale Progress.

To Taliesin West and the Frank Lloyd Wright Foundation.

To Continental Homes, Corporate Jets, Discount Tire Co., Eastman Kodak, Franchise Finance Corporation of America, Giant Industries, The Hyatt Regency Scottsdale, Mayo Clinic Scottsdale, The Perimeter Center, Pinnacle Paradise, Inc., Russ Lyon Realty.

For their friendly contribution or appearance: James E. Acridge, Annja, Chuck Bradley, Philip C. Curtis, Jeff Fleischer, Charles C. Gilhart III, Bruce T. Halle, Bruce Halle Jr., Earl Linderman, Aviva Rosen, Jill & Brittnee Schirripa, Fritz Scholder, Guy Stillman, musicians of the Phoenix Symphony, Lydia Torea.

For their assistance during the preparation of this book: Kamal Amin, Meg Black, Tim Bray, Constance Calhoun, Mrs. Ishik Kubali Camoglu, Richard Carney, Lisa Fisher, Donna Fleischer, Laurent Hallier and his team at American Lithographers, Thomas Houlon, Husberg Fine Arts Gallery, Kimberly Keim, Susan Q. Lacy, Ann Lane, Dixie Legler, Sherrill Lewis, Sue Livingston, Ivan Makil, Ann Morrow and David Harrison with the Scottsdale Artists' School, Pauline Mundy, Gary Nielsen, Al Olsen, C.N. Ray.

To my wife Donnalee, for her loving trust and support.

Grateful acknowledgment is made for use of the following quotations:
P. 8, Louisa Fletcher, *The Land of Beginning Again*, p.84 and Edgar A. Guest, *It couldn't be done*, from The Best Loved Poems of the American People, edited by Hazel Felleman, © Doubleday & Co., New York 1936 ; p. 19, Barbara Leslie Jordan, *Silver Song* from *Southwest Portrait*, Arkwright Press, Phoenix; pp. 20-21-24, from *Signature of the Sun, Southwestern Verse 1850-1950* © 1950, The University of New Mexico Press; p.22, Saint-John Perse, © 1977, Princeton University Press; p. 25-86, Misdee Furey; p. 46, Fritz Scholder, from *Afternoon Nap* © 1991, Nazraeli Press, Munich; pp. 53-71, Patricia Benton, p. 60, Jean Franck, p. 74 *The Oasis* (anonymous), p. 77, Maynard Dixon, p.81, J. William Lloyd, from *Arizona Anthem* by The Mnemosyne Press © 1982 Blair Morton Armstrong; pp. 64-75-109, Irene Welch Grissom, from *Under Desert Skies and Other Verses*, The Caxton Printers 1956; pp. 71-98, Patricia Benton, from *Medallion Southwest*, The Rydal Press, Santa Fe 1954; p. 73-80-113, Patricia Benton, from *Cradle of the Sun*, Fell, New York 1956; pp. 76-101, Sharlot M. Hall, from *Poems of a Ranch Woman*, Phoenix 1953; pp. 79-103, Harry Behn, from *Siesta*, The Golden Bough Press, Phoenix 1931; p. 107, courtesy of *Arizona Highways*.

Note of the Publisher: Most of the excerpts of southwestern poetry used in this book can be found in several different publications. Credit is always given to the author, whenever known, and to the publication most readily available. We apologize for credits we may have misinterpreted or omitted unintentionally.

Published by Bridgewood Press, an imprint of Sarda Resources, Inc.
4610 North 40th Street, Phoenix, Arizona 85018-3623 – Tel (602) 954-6573

Editor, Donnalee R. Sarda
Translation coordination, Detwiler Language Consultants

French	Sarda Resources, Inc.
German	Birgit I. Zimmermann
Spanish	Carmina Mendoza
Japanese	Japanese Communication Consultants, Inc.

Book design	Sarda Resources, Inc., Phoenix
Typesetting	Graphic Concepts, Phoenix
Color separations	American Color, Phoenix
Printing	American Lithographers, Phoenix
Binding	Roswell Bookbinding, Phoenix

Library of Congress Card Number 91-071662
Hard cover ISBN 0-927015-02-1
Soft cover ISBN 0-927015-03-X
Printed and bound in the United States of America.

This book is dedicated to the people of Scottsdale.

The world before me is restored in beauty.
Navajo Chant

Contents

The Past and the Promise

an introduction
by
Herbert R. Drinkwater

To those of us who have watched Scottsdale grow from a tiny enclave of saddleshops, galleries and citrus groves to a veritable oasis of spectacular resorts and world-renowned tourist destinations, it might seem as though some things will never be the same. On the other hand, if you look more closely, you could see that, in reality, some things never change.

Nowhere else will you find a warmer southwestern hospitality, a more sincere sense of caring, a stronger determination to overcome challenges, a rare and timeless sense of frontier adventurism, an uncompromising pride, an indomitable spirit of self reliance and folksy neighborliness.

To be part of the unique quality of life that is expressly Scottsdale, one need only experience the scenic beauty of the ageless McDowells, the textures and colors of the sky projected down onto the sheer rock walls of the mountainsides, the overpowering sense of the rich legacy left by noble Native Americans and rugged settlers.

I am frequently overwhelmed by the need to spend time with my family and our horses in the vast expanse of mesquite and cactus that characterize the high Sonoran desert. On horseback in the desert, I'm thrust back in time to a slower, simpler life, and I feel renewed in the values which served as the foundation for our modern Scottsdale. In these surroundings, confusion is given reason, and frustration gives way to hope and to dreams.

Last spring, we rode out to the ruins of an old home in the foothills where we watched the sun set over the entire city. I don't know that I've ever felt so fortunate and so blessed to hear the wind whisper and the coyotes call, the cicadas chirp and the owls hoot.

Scottsdale is less a destination than it is a journey – less bricks and mortar than a feeling of serenity and purpose. In many ways, like the breathtaking Sonoran sunset, its face is ever changing. You get a sense of a community that is continually on the road to discovery where anything seems possible, a place without limits, a new frontier.

I believe this book captures the essence of Scottsdale in words and pictures in a way that invites the reader to explore all we have to offer. You will note that *Scottsdale - a portrait in color* focuses on the people, as well as the landscape and architecture. To know Scottsdale, requires a full appreciation of the people, the land, the neighborhoods, and the rich and wonderful history that has transformed our town into a sparkling desert jewel.

As you enjoy your travels through Michel Sarda's photographic essay, let yourself discover the spirits of our city's past and envision the promise of its future.

Mayor Herbert R. Drinkwater

A Portrait in Color

by
Michel F. Sarda

Scottsdale is more than a city. It is a work of art: a mysterious combination of sensorial ingredients with the power to uplift and inspire – to make you feel, as the Navajos say, *in harmony* : harmony with the awe-inspiring desert scenery, with an educated and friendly community, with yourself. Unlike most magical places of the world, you won't see in Scottsdale man-made monuments and the art of centuries past – besides what nature itself has achieved. Rather, art here is in the making, and you become, whether you are a resident or a visitor, a part of it. The exhilarating sensation which results, I found many occasions to experience as a photographer during the preparation of this book. It comes with no surprise that so many artists choose Scottsdale for their permanent residence. They know these things.

Moreover, Scottsdale is a work of love. Created as such by its founding fathers, it truly was for them what Louisa Fletcher named the "Land of Beginning Again:"

> *I wish that there were some wonderful place*
> *Called the Land of Beginning Again,*
> *Where all our mistakes and all our heartaches*
> *And all of our poor selfish grief*
> *Could be dropped like a shabby old coat at the door,*
> *And never be put on again.*

Scottsdale has been built on an inspiring heritage. Along with the healthy sweat of the first settlers, Scottsdale's soil was tilled with solid civic and moral beliefs, strong community spirit and human values. All have resisted the eroding test of time.

Here, people assembled, acknowledged their affinities, and shaped their common vision. Groomed with loving care through generations, Scottsdale today is a one-of-a-kind, many-splendored city.

As an architect and city planner for many years, both in Europe and in the United States, I see Scottsdale as a city that has succeeded. The planting of a tree is also said to "succeed" when the seedling lives and grows; yet, recent history shows that it is much easier for a young tree to thrive than for a newborn town. In Europe after World War II, many attempts were made to create new towns. Although nurtured by milleniums of history and traditions, designed by some of the best architects of their time, funded and pampered by governments of advanced countries, most failed. Deprived of a community spirit from their inception, they evolved into bureaucratic monsters, and were quickly plagued with social problems.

Urban needs have become more diverse and volatile than before. Because the once-paramount necessities of defense, communications and food supply are now taken care of by the mechanisms of modern society, they are no longer an incentive to bring people together. In times of extreme individual mobility, it seems that only communities of interest, of spirit, of faith (Scottsdale's founder, Reverend Winfield Scott, was both a clergyman and a soldier), may initiate and nurture new cities; bureaucracy cannot. The very foundation of a city is its people. People make it happen, make it live, make it grow, make it rich. When people leave, a city – any city – dies. The Southwest is dotted with these ghost towns, once-bustling, now-abandoned places; tourists are their only and ephemeral visitors, along with the resourceful fauna of the wilderness.

In barely a hundred years, Scottsdale has become a success story in business and municipal management, in tourism, architecture, arts and crafts, Arabian horsebreeding and special events of all kinds. In a world with fading values, Scottsdale shines as an example of what can be achieved by people of inventiveness and conviction.

This community has attracted and continues to attract people of talent and merit. Among them, two visionaries interested in designing nature-conscious human settlements: Frank Lloyd Wright and Paolo Soleri. Although the visual impact of their work is still locally limited, their reputation and influence are worldwide.

In Scottsdale you experience a special relationship with nature – a nature with its own rules, offering either majestic sceneries or concealed beauties, denied to whoever passes by too hastily. This makes for a singular and most fascinating land, resembling a lovely stranger whose language you couldn't understand or just enough to perceive a great soul beyond the silent lips. Soon you discover that to know the desert is to love it – as you must love it to know it well.

Frank Lloyd Wright noted in 1928, while working on Dr. Chandler's San Marcos resort from the self-made camp he named *Ocatillo*:

> *... we have met the Desert, loved it, lived with it*
> *and made the Desert ours.*

The site, in its diversity, exudes a serenity of its own. Mediocrity and pretense, epidemics of urban life, do not belong here. For centuries, and perhaps more, people have lived here peacefully. The McDowells extend like an open hand to welcome you to this oasis, where nature has courteous manners and the desert is dressed up like a garden. A myriad of graceful plants teaches a lesson of stubborn survival. Limitless expanses of sky in ever-changing patterns and colors invite mind and senses to great schemes. As much as a challenge for the intellect and the imagination, this is a feast in all seasons, a place to relish with no petty restrictions, for the time you spend here is likely to linger in your memory like a perfume.

This photographic essay is structured as a visual and poetic chronicle. It has provided me all along with a stream of enlightening experiences. As can be expected, it has the merits and the limitations of a personal vision: an evocation more than a description – a highly subjective selection of photographs, most of them made during a specific period of time (October 1990 through June, 1991.) Also, it was impossible to include everything within the boundaries of a book: the people I met, the places I visited and discovered, the events I attended. Choices had to be made, often arbitrary, always painful.

Time is first to sign a portrait, whether it is of a person or a city – so projects under way are missing. Fragments of timeless southwestern poetry contribute their perennial charm to the instantaneous precision and unforgivingness of photography.

I thank the people of Scottsdale. Many contributed their experience and their vision, all shared their civic pride. I am grateful for the help and encouragements I received from a number of prominent members of this community. Credit must be given to the team of fine professionals who contributed in keeping the manufacturing of this book within our Valley area.

I also acknowledge the determination in times of doubt, the patience in times of discussion, the outstanding professional assistance provided to me at all times by Donnalee Sarda, my wife and partner. Without her this book would simply not exist. Let her share the pride after the anxiety; let her receive here my love and gratitude.

Michel F. Sarda

The First 100 Years

a brief history
by
Lois McFarland

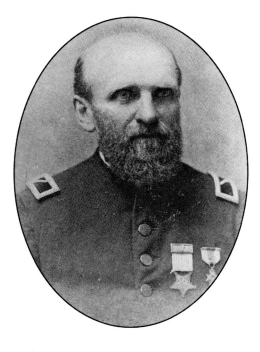

Chaplain Winfield Scott at the time he purchased the land that became the heart of Scottsdale. (Courtesy Scottsdale Historical Society)

Army Chaplain Promotes the Salt River Valley

More than a century ago when Arizona was still a territory and people believed there was nothing here but rattlesnakes and outlaws, an energetic parson rode around the Valley, liked what he saw and established roots.

The roots Army Chaplain Winfield Scott established following his first visit that February day in 1888, helped develop Scottsdale into one of the most desirable cities in America. The visionary had been invited to inspect homestead land east of Phoenix with the hope that he would help Phoenician promoters bring homesteaders to the territory.

On his journey that winter day, he viewed fields of alfalfa, crops of grain, orchards and vineyards. The fact there was no citrus intrigued him. He thought that with the Arizona Canal to provide water along with the dry climate and fertile soil, the land would be perfect for growing oranges and grapefruits. He was familiar with growing citrus in Southern California and believed it could be a lucrative business here.

Before leaving Phoenix in late June of that year, he put his vision to work by agreeing to pay $2.50 an acre for scrubby desert land some 12 miles northeast of downtown Phoenix. An agent filed his claim under the Desert Land Act of 1877 on July 2, 1888, at the U.S. Land Office in Tucson. The downpayment was $320.

This unnamed acreage – Section 23, Township 2 North, Range 4 East of the Gila and Salt River Base and Meridian – was destined to become the heart of Scottsdale.

On his journey to Pennsylvania and Ohio that fall, this one-man chamber of commerce extolled the virtues of the fertile Valley of the Salt River.

In the meantime, the Chaplain's brother,

George Washington Scott, arrived here in December, pitched a tent and became Scottsdale's first citizen in residence. G. W. Scott busied himself clearing away the greasewood, digging irrigation ditches and planting 80 acres of barley, a 20-acre vineyard, a 7-acre orchard and hedge of ornamental trees around the Scott homestead. This work was done with the help of friendly Pimas who lived on the reservation to the east of Scott's land.

By March of 1889, Chaplain Scott had asked for a transfer from Angel Island in the Bay Area of California to Fort Huachuca in Southern Arizona so that he could be closer to his new farming projects. By the time he reported to the fort, the Apache wars had been over two-plus years, and his attention centered on peaceful projects.

In addition to his preaching at the fort and in the community, he constantly wrote letters promoting the virtues of the Salt River Valley in hopes of convincing prominent easterners that Phoenix had something other than unfriendly Indians, scorpions, Gila monsters, and dirt and dust to offer new settlers.

Meanwhile, Scott's farming projects thrived. In 1893, the first commercial crop of peanuts in the Arizona Territory was harvested and the entire crop of 2,500 pounds sold at five cents a pound.

During this time, the Chaplain's old Civil War wounds flared up bringing to an end his ten years of military service. "The Fighting Parson," as he was known, had been wounded five times in the war, twice seriously.

He arrived in the Valley in January 1893 where he would live the rest of his life. His wife, Helen Scott, did not follow until early March, and when she did, it was to a home in Phoenix, not to ranch life in the desert. After she arrived, the two helped organize

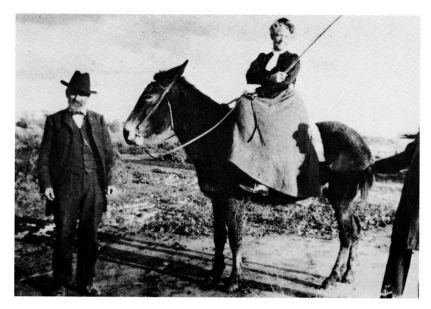

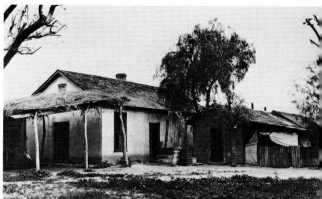

(above) The first home of Winfield Scott, made of adobe, was adjacent to their adobe cookhouse (circa 1897).
(left) Scott with wife Helen seated on Old Maud, the Army mule which retired with him in 1893.

(below) The first schoolhouse was built in 1896. Camelback Mountain is on the left.

(Courtesy Scottsdale Historical Society)

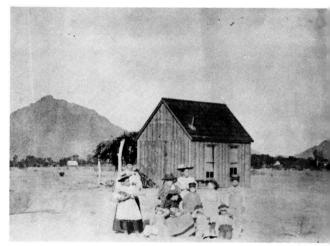

the Arizona Baptist Association, which until this time had been affiliated with the Baptists of Southern California. In April of 1894, he was elected moderator of the ABA, appointed to the group's mission board, and asked to serve as interim pastor of the Phoenix Baptist Church.

Scotts-Dale Is Named

The founder had done his job well. Helen Scott moved to the ranch and took her place as a leader of the small community. Easterners began settling the area that was known as Orangedale. They came for the clean desert air to get relief from upper respiratory conditions and tuberculosis, to try their luck at citrus farming, and as winter visitors boarding with homesteaders like the Scotts. This then, was the beginning of immigration to Scott's community and the start of today's resort business.

Between February and August of 1894, the townsite's name was changed from Orangedale to Scotts-Dale although some had suggested it be named Murphyville in honor of the Arizona Canal builder W. J. Murphy, or Utleyville after Rhode Island banker Albert G. Utley who subdivided the townsite. No one is certain how the name change occurred, but surely the credit must go to the town's few inhabitants, among them six ministers, a poet, a well-known pianist and an artist. All recognized that Winfield Scott was responsible for bringing prominence to this land.

The first land advertisement using the name as we know it today appeared in the *Phoenix Herald* March 1895 proclaiming in bold type :

SCOTTSDALE FRUIT LANDS NEW TOWN JUST STARTING!

The advertisement detailed the chance to buy undeveloped land or nearly mature orchards for the sum of $100 to $250 per acre.

School Bells Ring

Now that Scottsdale had a name and families began choosing the new town over life in the big city, the time had come for the settlers to consider a school. It was the spring of 1896 when the town's first citizens – the Tituses, the Blounts, the Davises, the Taits and the Scotts – established the Scottsdale School District.

As was the custom in frontier towns, the people volunteered their labor to build the first 16-by-18 foot wooden school house. In three days the building was finished and even before classes could convene, the one-room school was used for a religious gathering. When the school opened September 28, 1896, Alza Blount led eight pupils in the singing of "America." Mrs. Blount wrote in a journal commemorating the day: "The laws of the territory forbade the asking of Heaven's blessing upon this new enterprise, but young voices sounded out 'America' across the desert, thus striking the keynote of patriotism for Scottsdale."

From the simple notebook written more than 100 years ago, the idea to create a Scottsdale record of "historical incidents" was born. It was the hope of pioneers "that the trustees and friends of the school would continue the history through the years to come." (The original wooden schoolhouse, used for 13 years, today would be located ten yards east of the present "Little Red Schoolhouse" on the Scottsdale Mall which opened in 1909, and now is home to the Scottsdale Historical Museum.)

Businesses Emerge

The town's first wooden frame general store opened its doors in May 1897, operated by J. L. Davis. When banker Utley originally laid out the townsite, he included a deed restriction that prohibited the sale of alcohol. The townsfolk added further restrictions in May 1897 when 60 residents voted for prohibition and organized the territory's first Anti-Saloon League that June. "Alcohol would never get a foothold in this part of the Valley," was their firm belief, which followed the desire of their leader, Chaplain Scott, a life-long prohibitionist.

The General Store was purchased by Sarah E. Thomas in 1902, who became the village's first female postmaster. The institution of a post office in the area is credited with putting Scottsdale on the map. Two years later, postmistress Thomas sent for her sister Jane, who was married to E. O. Brown, and the pair helped her run the store. Mr. Brown became a mover and shaker in the community, building an ice plant onto the store, which was operated by the family for 32 years. Where the old store and ice

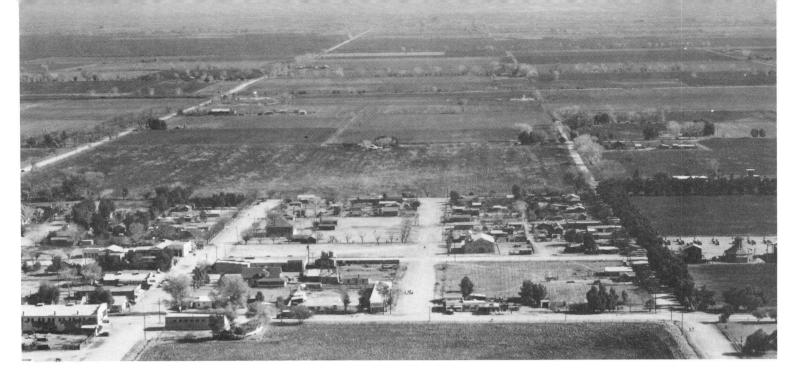

An aerial view of Scottsdale from the mid 1930s. The photo faces East. The road across in the foreground is Scottsdale Road, between Main Street (left) and Second Street (right). Our Lady of Perpetual Help is recognizable in the center. (Courtesy Scottsdale Progress)

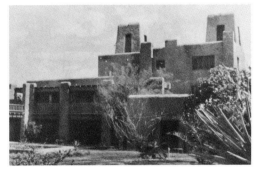

Jokake Inn in the 1930s. (Courtesy Scottsdale Historical Society)

plant stood, Arizona Craft Center emerged at Brown and East Main Street, thus starting an era that would to bring fame and fortune to Scottsdale.

Creative crafts started here in 1935 when Mathilde Schaefer arrived and set up the first kiln in Arizona. She began producing what became known as "Arizona Artware," pottery and sculptured pieces that today are considered collectors' items. Two years later, Mathilde met and married painter Lew Davis, thus joining together two artisans who became compelling forces behind the crafts movement.

The first art show took place in early 1950 at the Buck Saunders Trading Post & Gallery on Brown Avenue for a man who would become one of the best-known artists in the nation, Ted DeGrazia.

Other artists and artisans were R. Phillip Sanderson, woodcarver; Lloyd Kiva New, leather artisan; Philip Curtis, painter; Wes Segner, silversmith; and Christine Rae, textile designer.

The Arizona Crafts Center burned down in 1950 leaving craftsmen without a home, but not for long. With the help of Mrs. Fowler McCormick, Kiva New, his wife, Betty, and Wes Segner purchased two acres on an abandoned citrus orchard off Scottsdale Road and called it Fifth Avenue. The leather artisan built his own Kiva Craft Center around an ornamental pool and patio. Here, he envisioned artisans setting up their easels, potters wheels and weaving looms while visitors watched. This then was the beginning of now popular Fifth Avenue shopping area that today numbers more than 300 specialty shops.

Early Day Resorts

Since the earliest days of Scottsdale's development, vacationers were attracted to the area by its climate (85-degree average maximum temperature, 7 inches of rain, 86 percent sunny days) and clean air. From 1909 to 1938 the first resorts that lured tourists to the pristine desert were the Ingleside Inn, the Graves Guest Ranch, the Jokake Inn, Camelback Inn Resort, El Chorro Lodge and Kiami Lodge.

Of all the early guest lodges, Jokake, operated by Sylvia Evans Brynes, an artist and musician, who married architect Robert T. Evans, is credited with spreading Scottsdale's reputation far and wide.

Perhaps it was such distinguished guests as the Astors, Vanderbilts, Rockefellers, Ronald Coleman, Hedy Lamarr, Ginger Rogers, Milton Berle and Tallulah Bankhead that made it so appealing to others.

One guest, Frank Lloyd Wright, came each winter from Wisconsin and called Jokake home until 1938 when Taliesin West was started out in the virgin desert several miles north and east the then-Scottsdale boundary.

World War II Brings Changes

By the end of World War II, changes came quickly. In 1940, the town's population was about 743, but by 1950, it had jumped to just over 2,000 in city limits of less than one-square mile. Newcomers included personnel who had been stationed at Thunderbird Field during the war. They returned to live in the fledgling community.

Two men responsible for much of Scottsdale's post-war building and development in today's Old Town Scottsdale are Malcolm White and Earl Shipp. The town's first mayor, Mr. White, came up with the idea to create the western atmosphere of shake roofs, beam-supported porches and pine fronts. The western store fronts in turn helped promote the town's now famous slogan -- "The West's Most Western Town."

Along with the adoption of the slogan, came incorporation, economic development, and cultural and recreational amenities.

City fathers appointed to the first Town Council in 1951 were Mort Kimsey, Jack Sweeney, Bill Miller, E. G. Scott, with Mr. White chosen as mayor. Other mayors guiding Scottsdale through the years have been Mort Kimsey, William P. Schrader, John Woudenberg, C. W. Clayton, Dr. Bud Tims, Bill Jenkins and "Mr. Scottsdale," Herb Drinkwater, who has served as mayor since 1980.

The Scottsdale Chamber of Commerce, recognized as one of the nation's most successful chamber organizations, was founded in 1947. Dave Hallstrom contributed greatly to the chamber's success in the late 1950s and again in the 1980s as its director. In 1958, it had but twenty members, two employees and a budget of $2,000. While in the 1990s, the chamber's membership exceeds 2,000; director Phil Carlson has a staff of more than 30

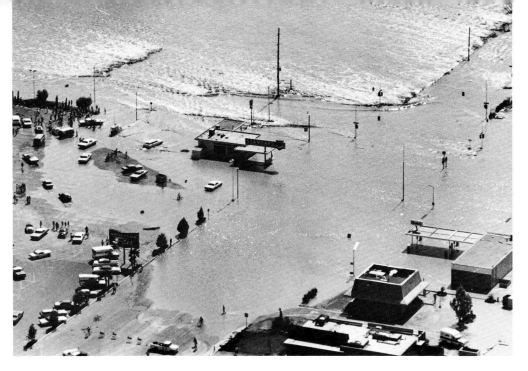

The dramatic flood of June 1972, expedited the realization of the Indian Bend Wash Greenbelt, a floodwater control project which had been a controversial issue for years.
At right, an aerial photograph shows the effects of an earlier flood.

(Courtesy Scottsdale Progress)

employees; and a budget of approximately $4 million.

After incorporation in 1951, the city fathers saw the need to upgrade the mostly volunteer fire department. Meanwhile, a young newspaperman named Lou Witzeman, who became angry when a neighbor's house burned down because no one responded to the fire, decided to start a subscription fire department. In 1948, he purchased a fire engine, hired three men and started Rural/Metro Corporation. In 1951, Scottsdale became Mr. Witzeman's first full-service contract. Today Rural/Metro, headquartered in Scottsdale, is the largest contract fire service in the nation serving several states.

Faces of Scottsdale

The village wouldn't have become a town, nor the town a city without the pioneer spirit shown by early day merchants, blacksmiths, cattlemen, educators and proprietors. Some of these were George Cavalliere, Alvaro and Jesus Corral, Jew She Song, George Judson, Roy E. Peterson, William E. Kimsey, George Willmoth, Harvey Noreiga, Howard and Ida Underhill, Clara Beauchamp, Lester Mowry, Thelma Holveck, Vomen Frye, Garland White, Grace Thomas Crews, and Mittie and Wilfred Hayden.

From the late 1940s to 1960s people such as William Messinger Sr., an attorney and dairy farmer; Patricia Benton, poet and writer; Luther "Lute" Wasbotten, pharmacist and councilman; and Bill Donaldson, city manager were among Scottsdale's faces that made a difference.

While Scottsdale's government took shape, large ranches were being purchased as Arabian horse showplaces and as cattle ranches. These pioneers were the Fowler McCormicks, the Daniel Gaineys, the Bob Astes, Eugene LaCroix, Dorothy Wrigley and Tom Chauncey.

Both the McCormicks' 4,000-acre ranch and the Gaineys' 600-acre spread have since been developed into planned communities and are a showcase of residential and commercial development.

Among those pulling up stakes in the East and Midwest to bring their families to Scottsdale in the late 1940s were Russell A. Lyon Sr., a big band musician from New York, turned real estate broker; and G. Robert Herberger, who owned a chain of department stores in Minnesota, South Dakota and Chicago, turned developer. In the 1960's Jerry Nelson, a Michigan commercial contractor, purchased what is now most of northern Scottsdale, started a water company, and began developing showplace communities and golf courses.

The Modern Era

As the desert was subdivided and turned into luxury resorts, golf courses and homes, Scottsdale established regulations to protect the Sonoran Desert and its underground water source.

The city became known for its destination resorts including The Registry, Scottsdale Conference Resort, Hyatt Regency Scottsdale, Scottsdale Princess and Boulders; for its cultural amenities such as the Scottsdale Center for the Arts, and for the establishment of a healthcare capital, beginning in 1961 with City Hospital of Scottsdale, later to become Scottsdale Memorial Health Systems, Inc. In 1987, Mayo Clinic Scottsdale opened its prestigious center in the northern part of town.

Tourism remains the city's number one industry. Visitors come from all over the world to view nationally recognized events including the Phoenix Open at the Tournament Players Club, the Tradition Senior PGA, the All-Arabian Horse Show, the Barrett-Jackson Auto Classic, the Scottsdale Jaycees Parada del Sol and

Rodeo, All Indian Days, Cactus League Baseball, the Scottsdale Culinary Festival, and World Champion Tennis, as well as numerous horse-related events at WestWorld.

By the city's one-hundredth birthday in 1988, population had reached 126,000; by 1990-91, 132,000 with an expected 177,000 by the year 2000. Scottsdale is the second largest city in total miles in the state with 185 square miles and sixth largest in population.

"Good communities such as Scottsdale do not just happen," said former Mayor and historian Bill Jenkins. "They are built and nourished by a citizenry that cares."

By the same token, another Scottsdale historian Richard Lynch, author of *Winfield Scott, A Biography of Scottsdale's Founder* said: "His oasis in the desert has become a prospering community with a bright future."

Indeed it has!

Lois McFarland

Lois McFarland is an award-winning writer, author and photographer who has written for more than 30 years for a variety of print media. She is a columnist for the *Scottsdale Progress* newspaper.

Index of Color Plates

Note: The numbers on the map show the locations where the photographs where taken. Each refers to the page on which the photograph appears, as listed above.

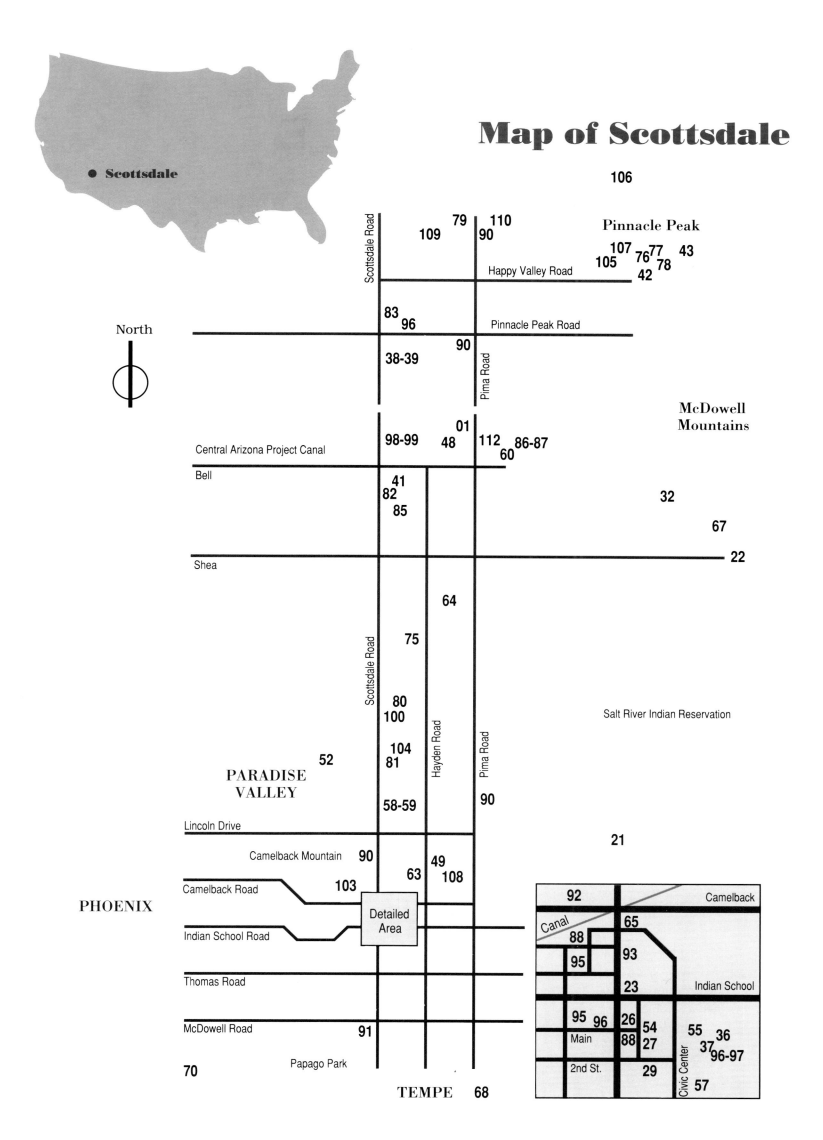

Map of Scottsdale

106

Pinnacle Peak

Scottsdale Road

79
109
110
90

107 76 77 43
105 78
42

Happy Valley Road

83
96

Pinnacle Peak Road

90
38-39

Pima Road

North

McDowell
Mountains

01
98-99 48

112 86-87
60

Central Arizona Project Canal

Bell

41
82
85

32

67

22

Shea

64

75

Scottsdale Road

80
100

Hayden Road

Salt River Indian Reservation

104
81

52

Pima Road

PARADISE
VALLEY

58-59

90

Lincoln Drive

21

Camelback Mountain 90

49
63 108

Camelback Road

103

PHOENIX

Detailed
Area

92

Camelback

Canal

65

Indian School Road

88

95

93

23

Indian School

Thomas Road

95 96

26
54

55 36
37
96-97

McDowell Road

91

Main

88

27

Civic Center

Papago Park

70

2nd St.

29

57

TEMPE 68

17

This is a country of space, space beyond mountains,
Space in wide deserts, unlimited reaches of sky,
This is a world where heat in undulant fountains
Of quivering light assaults the timorous eye.

Barbara Leslie Jordan

Legacy

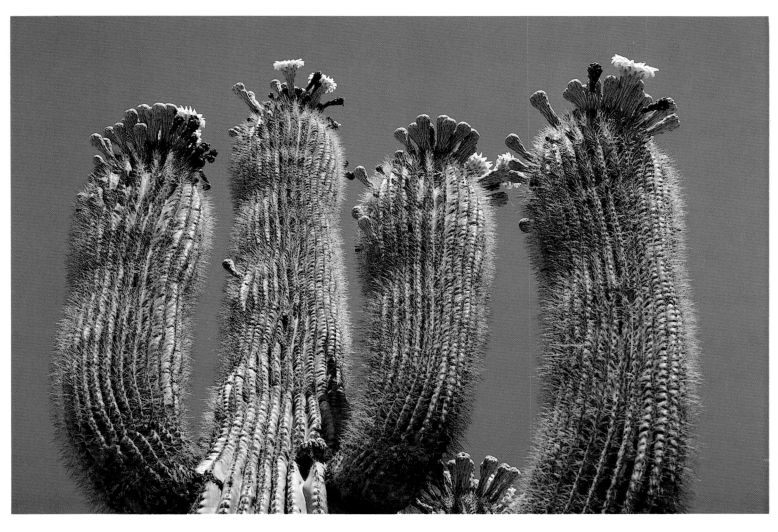

Sunshine, give me both
Your hands
To lift the flowers I need

Hopi Prayer

In springtime flowers bring an unexpected smile to
the weathered skin of the giant saguaro cactus.
(photo Alan Benoit)

(pages 18-19)
First was the land, the Sonoran desert.
(photo Michel F. Sarda)

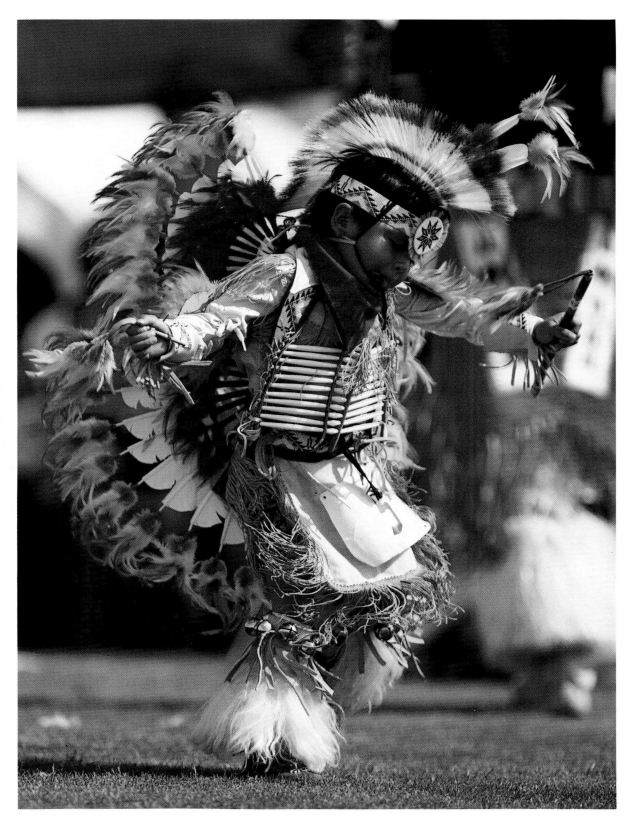

They weave the thunder in the basket,
 And paint the lightning on the bowl:
Taking the village to the rainbow,
 The rainbow to the soul.

Haniel Long

Native American cultures contribute grace and
harmony. A five-year old Navajo boy dances at the
annual Scottsdale Pow Wow.
 (photo Brad Armstrong)

All the nubile and vigorous land, at the step of the Stranger,
opening up the fable of its grandeur to the dreams and pageantries of another age,
And the land in its long lines, on its longest strophes, running …
to loftier scriptures, in the distant unrolling of this world's most beautiful texts.

Thus was the City founded and placed in the morning
under the labials of a clear sounding name.

Saint-John Perse
(translations by T. S. Eliot and Hugh Chisholm)

22

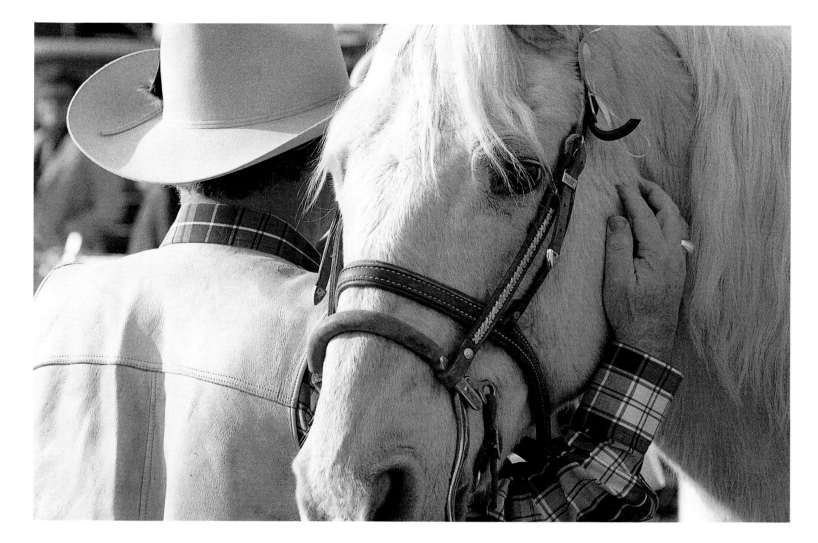

A bond of love, of legends
and of mystery;
A silent speech of past adventures
and future chances.
It is the Horse that has carried us
through mortal history
And in our souls, it is the Horse
who prances.

Misdee Furey

The virile friendliness between man and horse was
nurtured by generations of shared hardship.
(photo Michel F. Sarda)

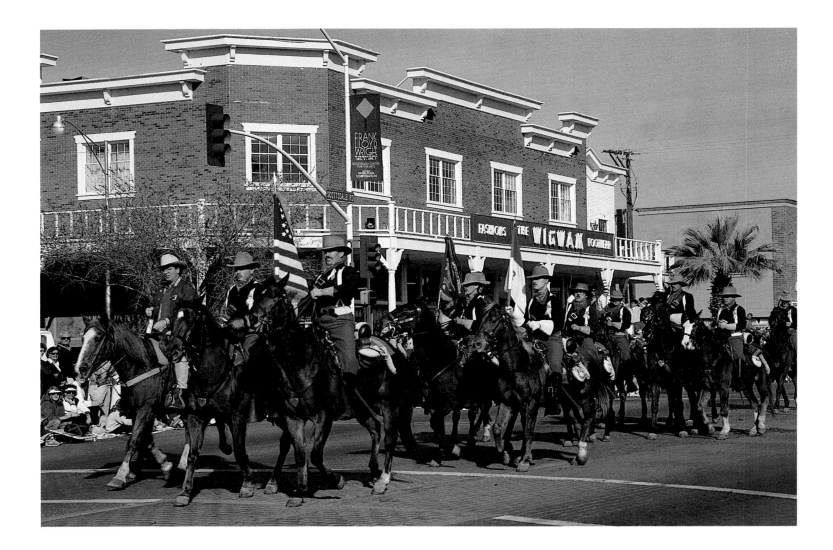

The largest horse-drawn parade in the world, the
Parada del Sol offers every year an opportunity to
revive colorful moments of history. A detachment
represents the 4th Regiment of the U.S. Cavalry,
based in Fort Huachuca, which captured the Apache
chief Geronimo in 1886, two years before Scottsdale
was founded.

(photo Michel F. Sarda)

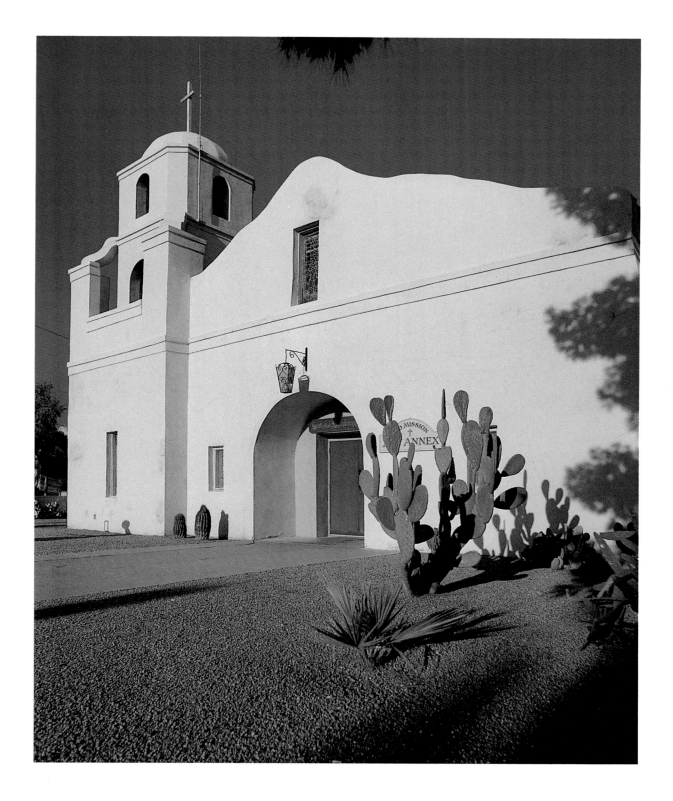

Our Lady of Perpetual Help, Scottsdale's first
Catholic church, was built in 1933 by Mexican
immigrants who made by hand the 14,000 adobe
bricks of the original building. It is home today to
the Scottsdale Symphony Orchestra.

(photo Michel F. Sarda)

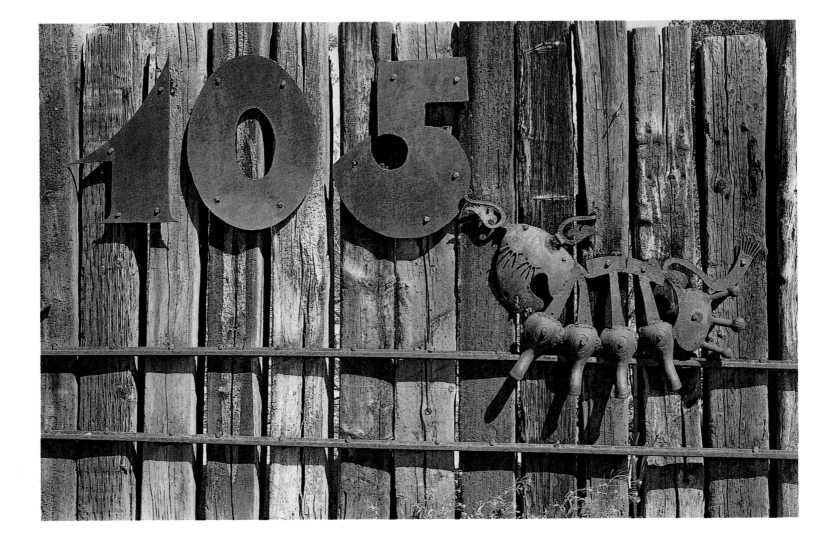

The house that engineer George Ellis built for his family in the 1930s was made of redwood slabs retrieved from the nearby canal. By the gate on Cattle Track is displayed ironwork by sculptor Ron Hadgerty.

(photo Michel F. Sarda)

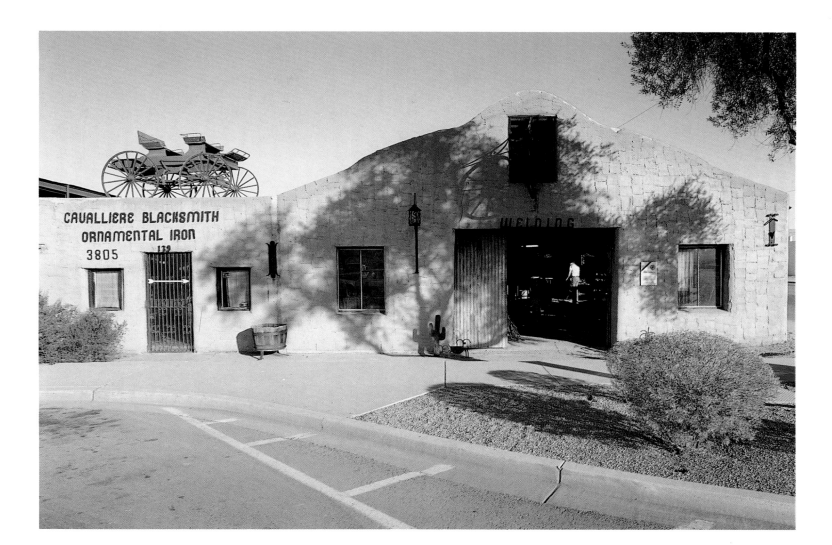

The oldest business in continuous operation in Scottsdale is the blacksmith shop started by George Cavalliere in 1910. It was built "out on the edge of town," in compliance with the instructions of the city founders.

(pages 30-31)
The home of artist Jessie Benton Evans became the Jokake Inn in 1927, Scottsdale's second in-town resort. It soon attracted celebrities from all over the United States. The towers are now a distinctive landmark on the grounds of the Phoenician resort.
(photos Michel F. Sarda)

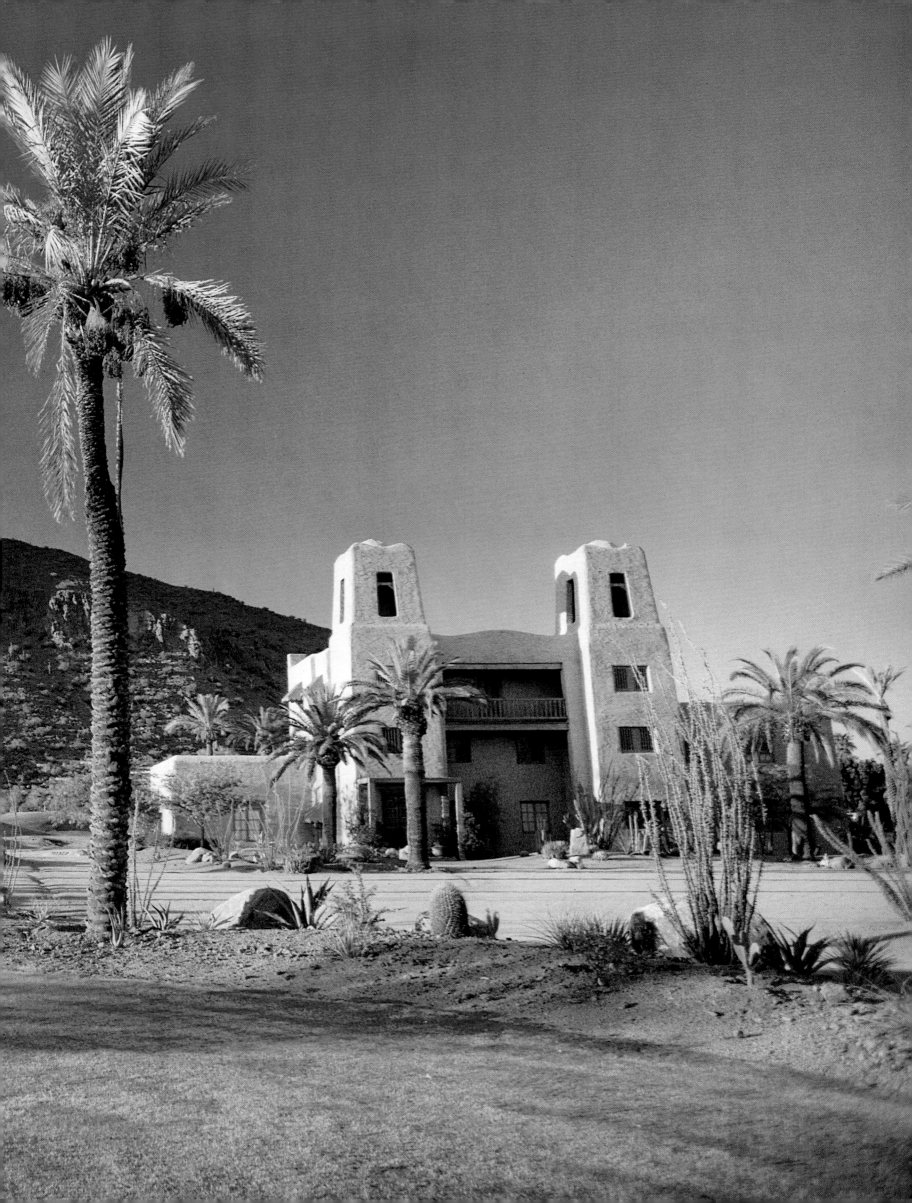

When Frank Lloyd Wright arrived on the Arizona desert in the winter of 1937, and discovered a beautiful tract of land up against the McDowell mountains north of Scottsdale, he was determined to make Arizona his winter home, studio and workshop. Ten years earlier he first experienced this region while working as a consultant on the Arizona Biltmore Hotel. Again in 1934 he returned to the southwest, this time to Chandler, where, with his wife Olgivanna and the apprentices in their school, the Taliesin Fellowship, he worked on the plans and models of Broadacre City, his visionary design for the decentralized city set into the landscape. He was convinced that this southwest region would be the ideal winter location for the Fellowship in strong contrast to the hard, bitter winters of their native Wisconsin.

With him that winter of 1937 were his apprentices, about 34 young men and women from all across the nation and around the world, studying architecture through an experiential training that included building construction, as well as architectural drawing. There was little money at hand, barely enough to purchase some 600 acres of unspoiled desert and rudimentary building materials. But there was an abundance of much hard labor — on the part of the apprentices themselves — and the strong desire to build a new building for their home and studio.

Thus Taliesin West grew, right out of the desert itself, its massive walls made of the stones scattered along the desert floor and upon the sides of the foothills behind. Sand from the desert washes was mixed with cement to hold the flat surfaced stones in place as they composed a rugged mosaic in harmony with the features of the natural landscape.

Taliesin West expanded as the Fellowship grew from 34 to 65 members, and changed annually as Wright returned each fall from his Wisconsin summer and saw new and better ways to improve the building. It began as "camp", broad-based strong stone walls supporting the canvas and redwood roof structures. Water came, as it does today, from a deep well on the property, and electricity, until recently, was generated on site.

Now Taliesin West, the winter headquarters for the Frank Lloyd Wright Foundation, is outfitted to be a living, working place for twelve months of the year, although the greater part of the Fellowship returns to Wisconsin each summer. Once isolated and practically undiscoverable out on the desert, Taliesin West today has become a major touring attraction in Arizona. An ongoing program, active year round, serves the visitors, architects, students and scholars who come to see the buildings where Wright worked and lived each winter for the last 22 years of his life. It is also the home base for the Frank Lloyd Wright School of Architecture, the Frank Lloyd Wright Archives, and the Taliesin Architects.

<div align="center">Bruce B. Pfeiffer
The Frank Lloyd Wright Archives</div>

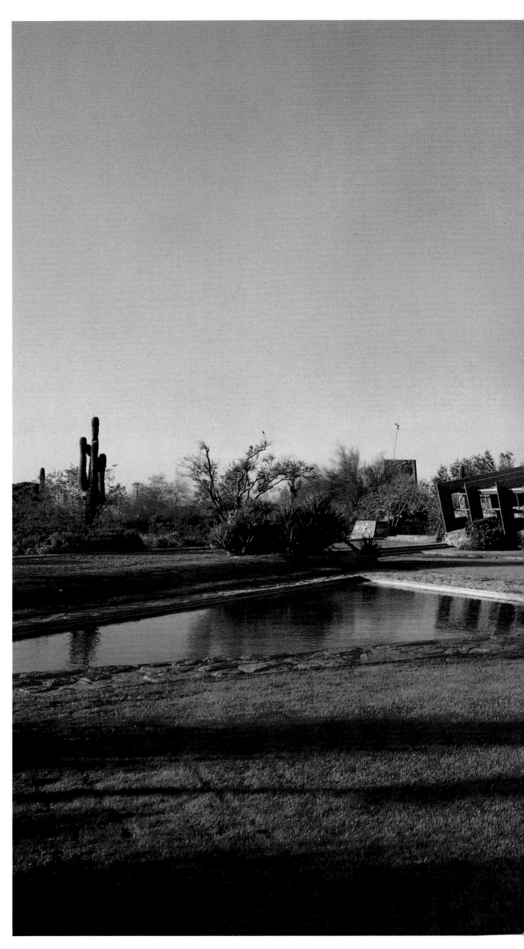

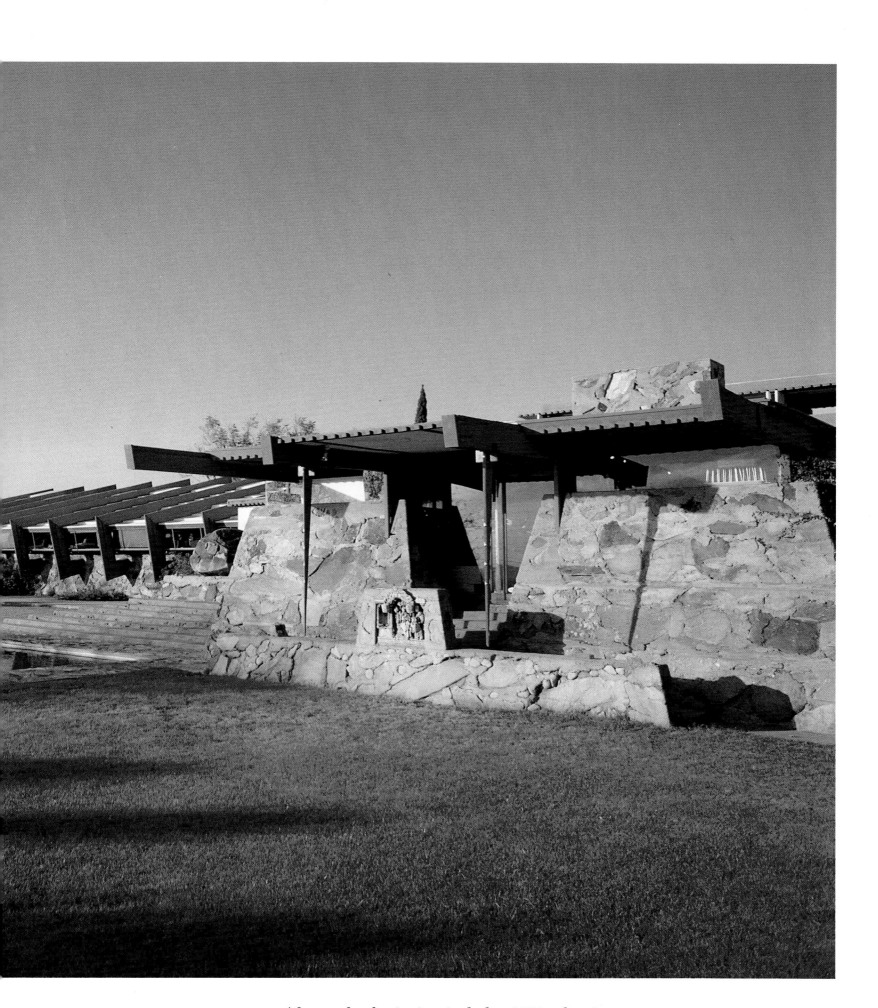

After modest beginnings in the late 1930s, the winter
home, office and school of architect Frank Lloyd
Wright was the first site in Scottsdale to be listed on
the National Register of Historic Places. In 1982, it
was designated as a U.S. Landmark.
(photo Michel F. Sarda)

People

Congratulations, Scottsdale!
Just look at you now!
Camelback Road was just dirt.... The
population topped at around 2,000 men,
women and children... and Sidney P. Osborn
was governor.

It was orange blossom time when my father,
Russ Lyon, Sr., brought his young family to
Arizona in March of 1947. Our first home
was made of simple adobe.
Russ was a pioneer entrepreneur who saw
the need to help this fledgling community
develop. A former musician, he opened the
doors to the first family-owned real estate
brokerage in the Valley, which still bears his
name. Other fine families joined in creating
the new city.

Since those dusty days, we've seen the
changes and experienced the growth of their
visions. The community blossomed into The
West's Most Western Town.

Scottsdale, we are ever mindful that what we
do today shapes your tomorrow. We also
recognize what makes this city so great - your
people!

Dennis H. Lyon
for the Lyon family

A young lady imagines her future achievements at
the Hyatt Regency resort's sand beach.
(photo Michel F. Sarda)

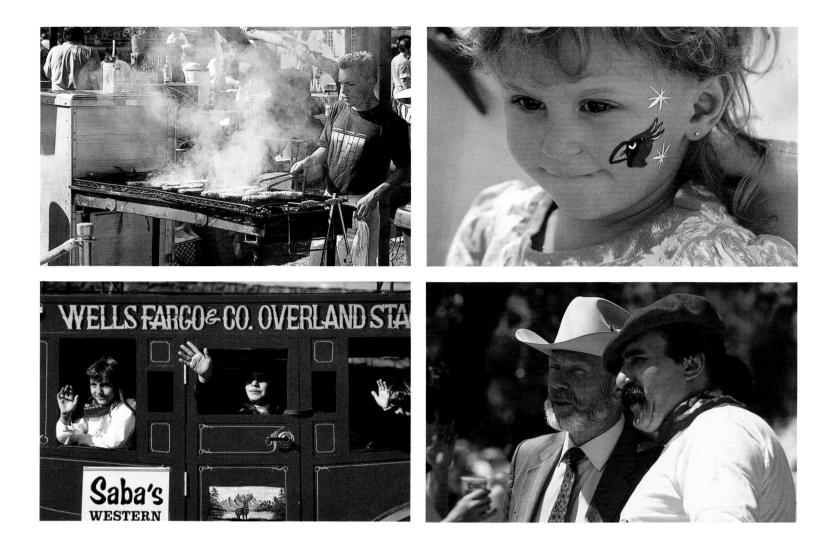

People of Scottsdale are dedicated, creative and playful. From top left, clockwise:
– A staff member of the Scottsdale Cultural Council operates a barbecue at the Arts Festival.
– Young Heather proudly heralds the colors of the Cardinals, Phoenix's NFL team.
– Mayor Drinkwater opens a gastronomical agenda with chef Gutierrez at the Culinary Festival.
– Passengers of the Wells Fargo stagecoach enjoy the ride during Parada del Sol.
 (photos Michel F. Sarda)

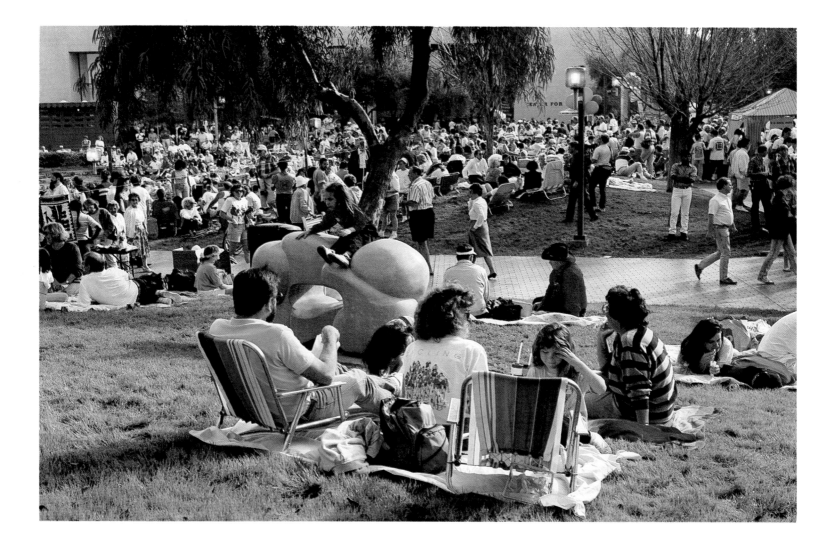

From October to May, the grounds of Scottsdale
Mall welcome a variety of well attended events.
(photo Michel F. Sarda)

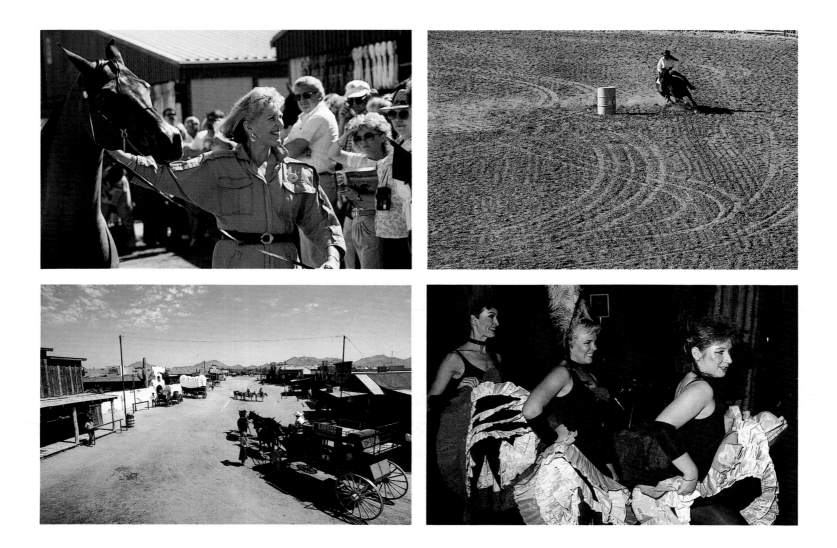

Clockwise from top left:
– A young Arabian horse is led with pride to an award presentation at the All-Arabian show.
– During rodeo time, young riders compete in the barrel race.

(photos Michel F. Sarda)

– Jovial dancers revive a spicy western tradition.
– The theme village of Rawhide – or how the West was fun!

(photos Alan Benoit)

(opposite page)
Arizona's sunshine allows year-round outdoors activities. Here, a visiting group is treated to a giant barbecue.

(photo Alan Benoit)

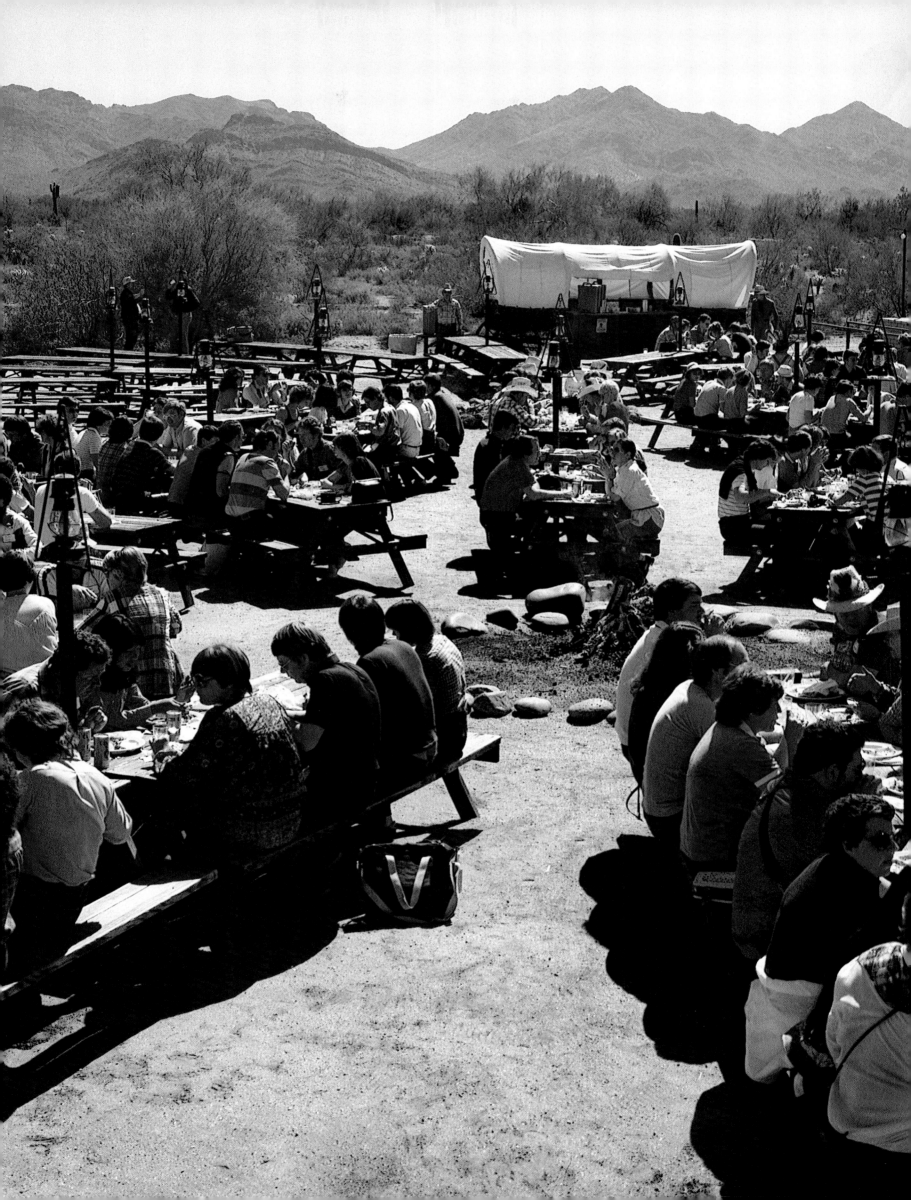

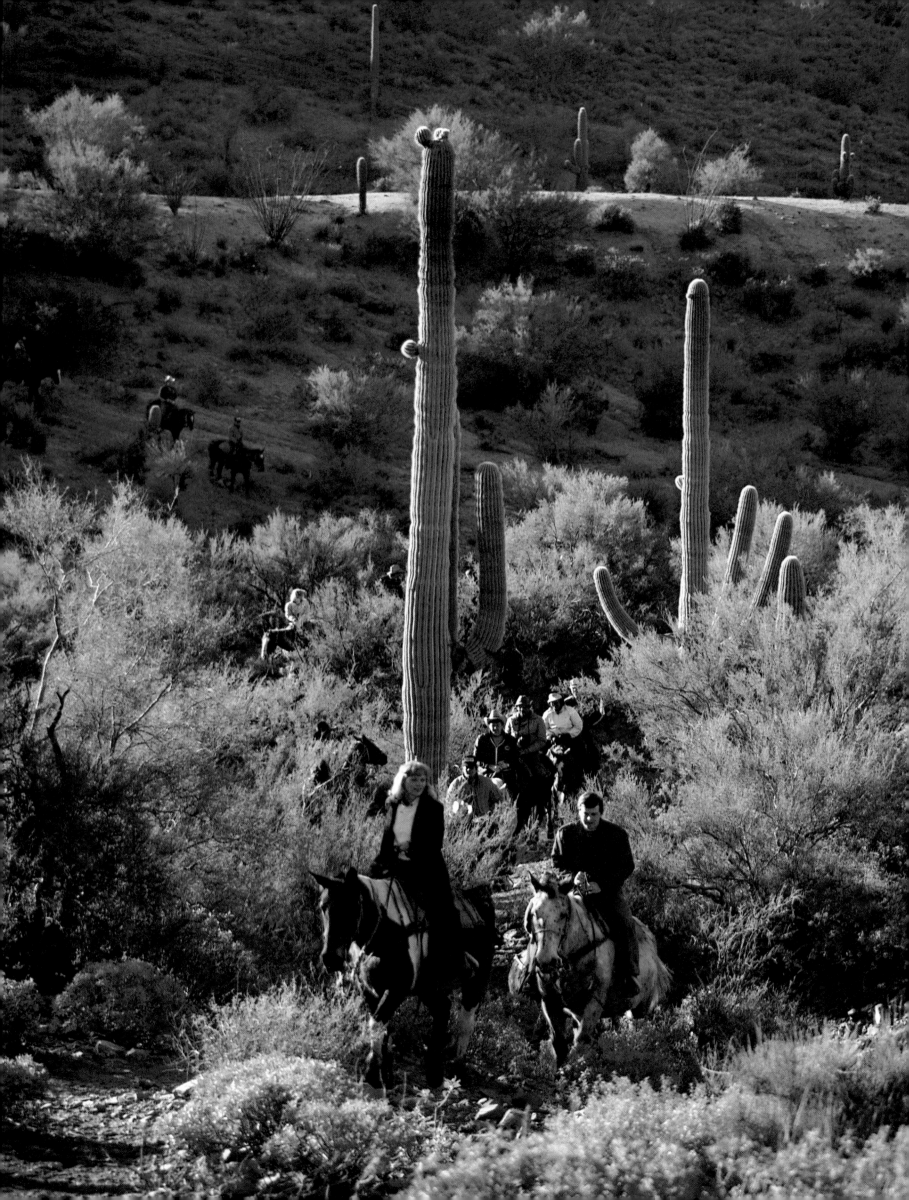

Busy executives launch their day at Scottsdale
Municipal Airport.
(photo Michel F. Sarda)

(opposite page)
Minutes from the office, trailriders take a break
from urban life.
(photo J. Peter Mortimer)

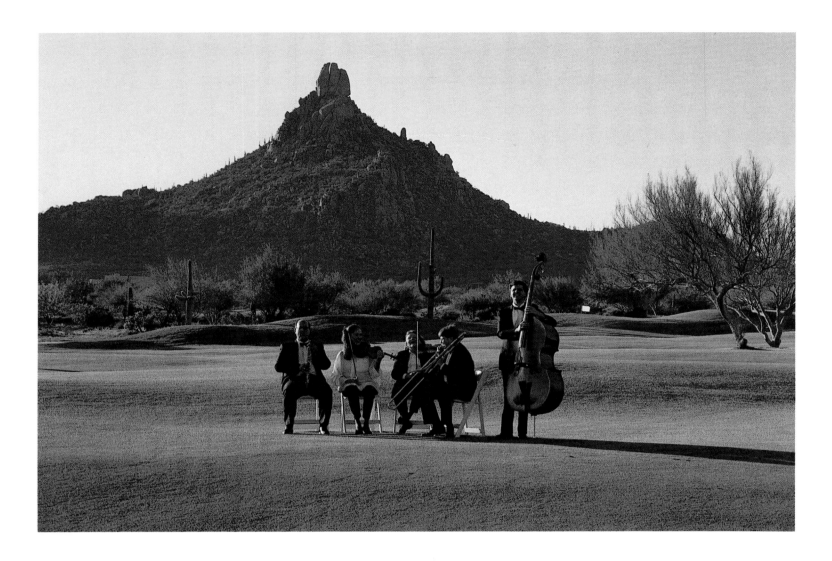

In a Felliniesque setting on Troon golf course, with Pinnacle Peak as a majestic backdrop, Phoenix Symphony musicians joyfully rehearse a somewhat improbable piece prior to an outdoors performance.
(photo Michel F. Sarda)

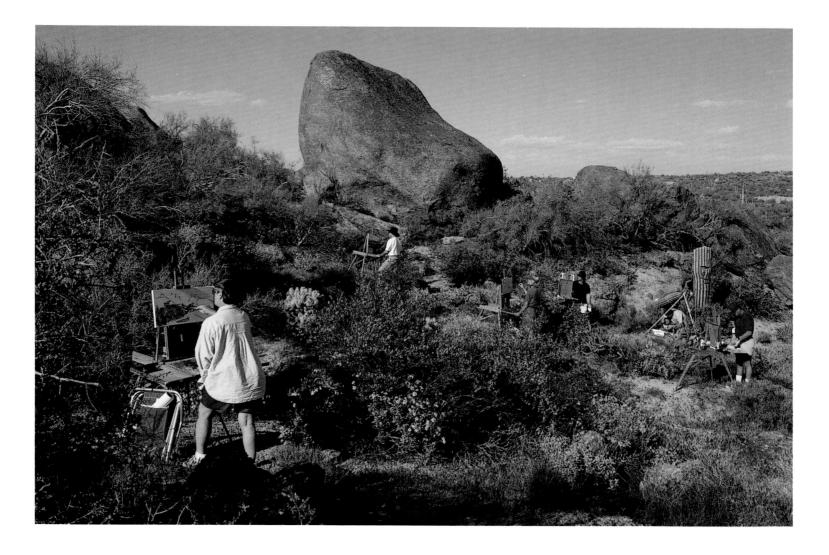

Artists find the desert scenery an inspirational
subject, like these dedicated painters from the
Scottsdale Artists' School.
(photo Michel F. Sarda)

In 1961, the Philip C. Curtis Fund was developed through the creative thinking and the energy of Lewis J. Ruskin. At this time, the painter was struggling and unable to sell his work. Ruskin thought Curtis has the insight and talent to be a terrifically capable artist if only a chance could be provided for him to devote full time to his art. Ruskin's idea was to bring together ten community citizens who would sponsor Curtis through the Trust which was to be set up... The ten patrons had first options to buy other paintings during the years following. This they did.

James K. Ballinger
Director, Phoenix Art Museum

Philip C. Curtis was one of the first artists to settle in Scottsdale in the 1930s. His sensitive surrealistic art has brought him world-wide recognition.
(photo Michel F. Sarda)

Snake Lady
a classic portrait
of loveliness and beauty
She always made sure
that she looked like
a million bucks
It was spring the
weather was perfect
sunshine
Her lips trembled
when she remembered
her date with Thrill
tonight
Mmmmmmmmmm
She could taste it.

Earl Linderman

Earl Linderman creates from his imagination a
colorful and sensuous world, inhabited by humor
and nostalgia.

(photo Michel F. Sarda)

Everywhere the shadows constantly wait for me to lie down and let go.
Fritz Scholder

French sculptress Annja joined recently the cosmo-
politan community of artists who elected Scottsdale
as a place of inspiration. She divides her time
between her studios in Scottsdale and the French
Riviera.

(opposite page)
World-known artist Fritz Scholder explores a
Shakespearian universe of human figures tormented
by the powers of color.

(photos Michel F. Sarda)

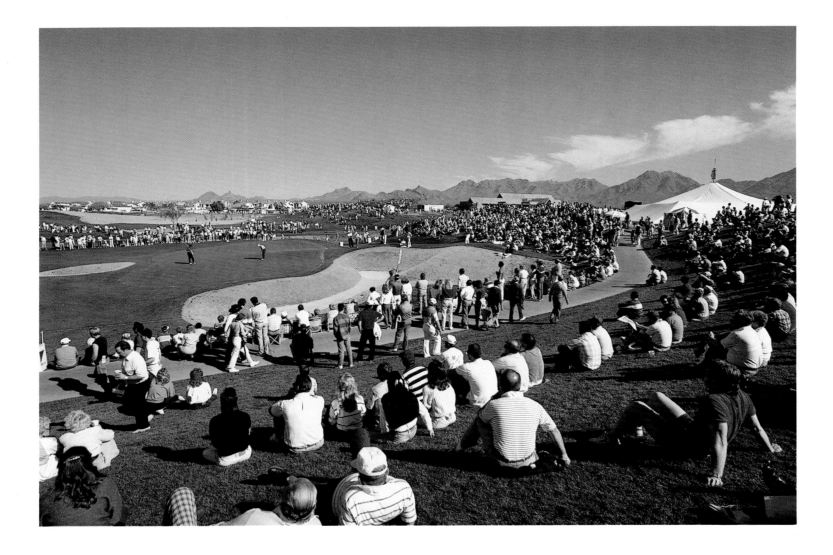

Some of the world's best players are attracted each year to Scottsdale's golf tournaments. The Phoenix Open represented here attracts its share of golf aficionados.

(photo Alan Benoit)

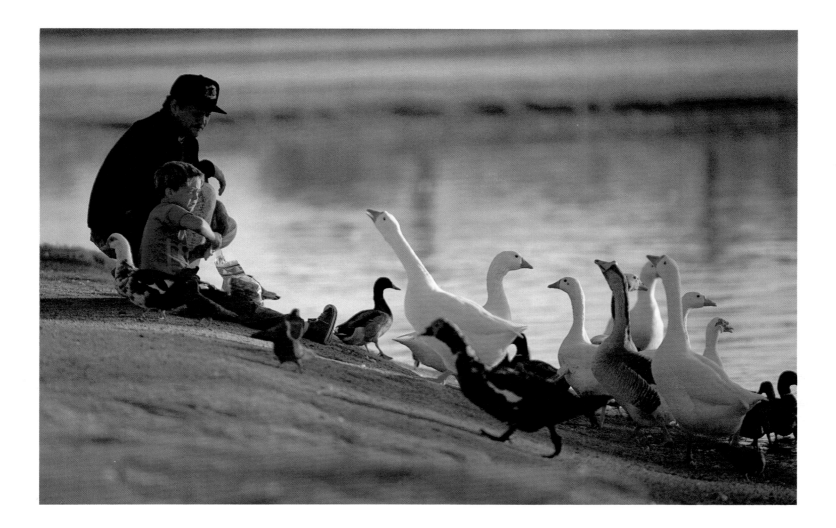

Father and son introduce themselves to the popular
tenants of Chaparral Park.
(photo Michael Mertz)

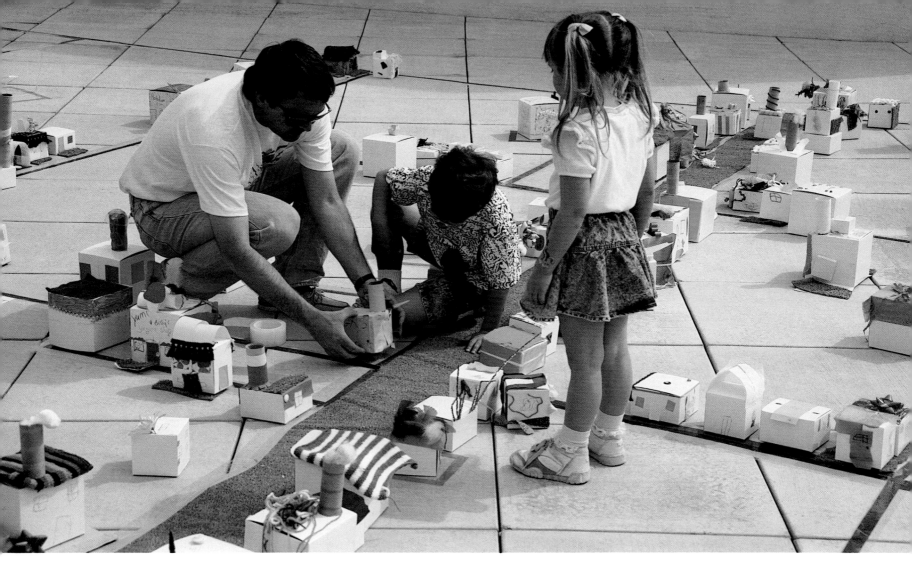

(above)
Designing a beautiful city is everyone's business.
Youngsters are introduced to city planning at the
annual Arts Festival.

(pages 52-53)
Over the years, Scottsdale has expanded to the
north, to the foothills of the McDowell Mountains.
In the distance, Four Peaks' towering outline.

(photos Michel F. Sarda)

Community

Golden mountains in the summer,
Purple mountains in the winter;
Fleecy white thunderheads in August,
An artist's palette of color in spring;
The gentle song of the dove at dawn —
And the glorious blaze of vibrant color of the sunset;
Saguaros silhouetted against the pastel sky at dusk ...

A caressing sense of tranquility envelops the land
as the jet black of the night sky
enhances the iridescent sparkle of the stars ...

All to be enjoyed and savored amidst the vigorous
community of vision,
Scottsdale.

Mae Sue Talley

The tide of faith has washed this timeless shore,
Revealing answer of unsealed desire,
In lock of silence at the desert door
Is clasped the hidden pulse of sentient fire …
Beyond uncertainties the certain path
Is vision that compels the seeker's eye
Daring to climb in spite of tempest-wrath
The height that will impel a known reply:
And in the proud insistence of the tide
No heart and no man's spirit is denied.

Patricia Benton

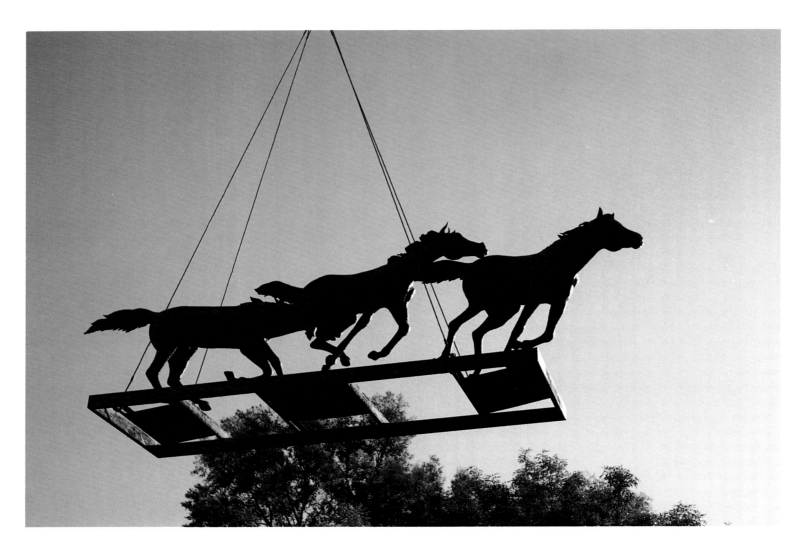

Nothing is stagnant in Scottsdale because the complexion of the city is rapidly changing. It's more than just "The West's Most Western Town," it's the country's most art-filled town, home of the Scottsdale Center for the Arts, a national model of private and public cooperation.

The arts are everywhere in Scottsdale, with something for each and every one to enjoy – from arias to zydeco. You are never more than a block or two away from examples of the many fine public art sculptures, both privately and publicly funded. Private art galleries nurture our cultural diversity. Outdoors and in, nightime and daytime, for residents and visitors, our lifestyle is richly enhanced by Scottsdale's commitment to the arts.

Councilman Sam Kathryn Campana

Yearlings by Arizona artist George-Ann Tognoni, here being installed, was dedicated in 1987 after a successful community fund raising. It marks the entrance to Scottsdale Mall on Brown Avenue.

(photo Sonny Ness)

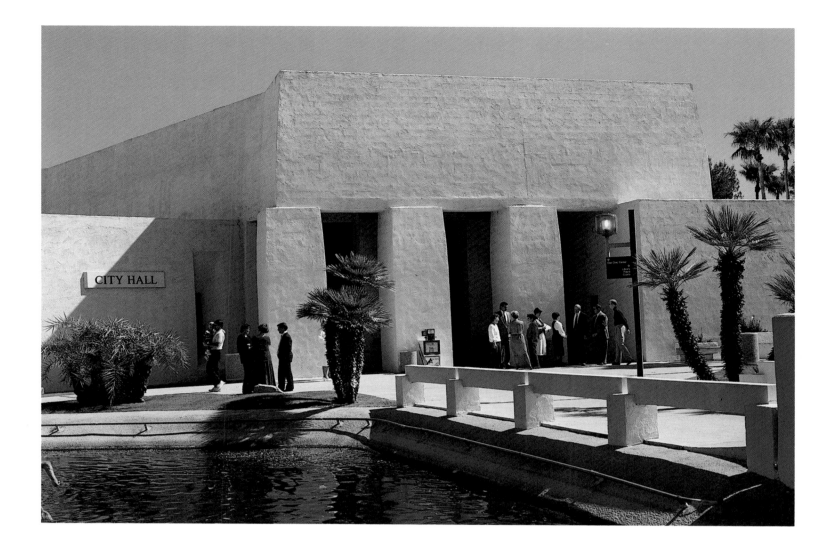

Citizens and officials discuss in front of City Hall.
The Civic Center complex, which includes a library
and arts center, was designed by architect Bennie
Gonzales and completed in the mid-1970s.
(photo Michel F. Sarda)

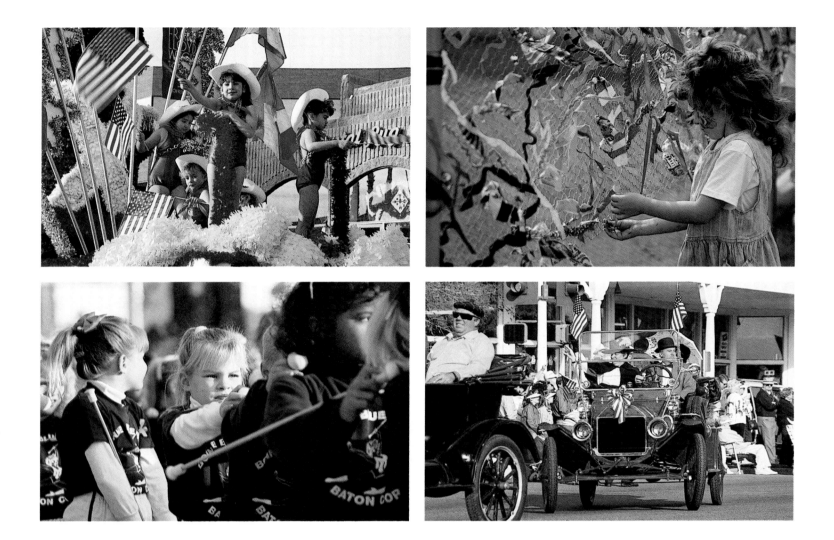

Community participation takes an early start and
does not stop. Clockwise, from top left:
– Staffing with charm a Parada del Sol float.
– Creating an "ecological fence".
– Sharing the pride of collecting vintage cars.
– Rehearsing the parade – serious business!
(photos Michel F. Sarda)

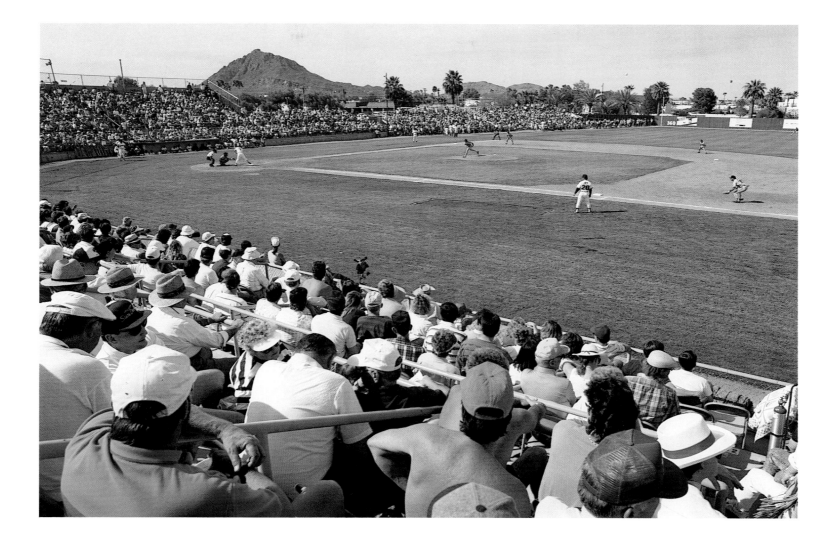

Arizona's Cactus League baseball games are an
opportunity for the San Francisco Giants, at home
in Scottsdale for spring training, and the Cleveland
Indians to meet in the old Scottsdale stadium, before
a new one is built and ready for the 1992 season.
(photo Michel F. Sarda)

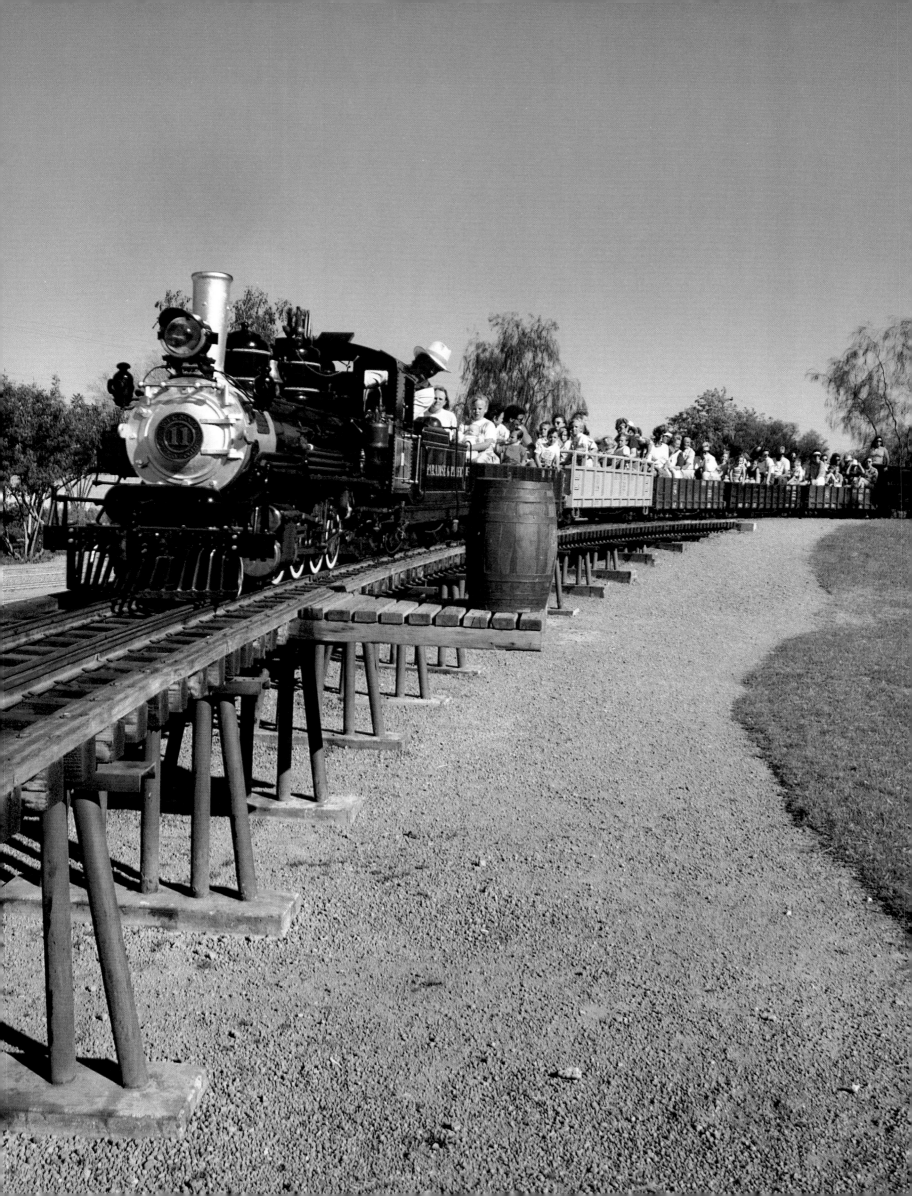

Clockwise from top left:
— The Baldwin locomotive displayed in the McCormick Railway Park was built in 1907. After serving a long career hauling mining ore throughout the Southwest, it was retired in 1961.
— Guy Stillman, initiator and designer of the Park, shows nostalgia for the great railroads of the past, on the platform of the Roald Amundsen car, used privately by presidents of the United States and other prominent passengers. This Pullman car was donated to the Park by the Franz G. Talley family.
— Children show interest in another means of transportation following pure western tradition.

(opposite page)
The Paradise & Pacific carries more than 160,000 visitors around the popular McCormick Railway Park every year.

(photos Michel F. Sarda)

It is a chandelier sky
With infinite dimensions of prisms
In frozen suspension
Only diamond edges of air stir
To light the blue crystals
Breathe softly
A sigh
Could crack this polished day.

Jean Franck

The American Cancer Society balloon race takes off
into the ever-blue Arizona morning sky from
WestWorld's polo field.

(photo Michel F. Sarda)

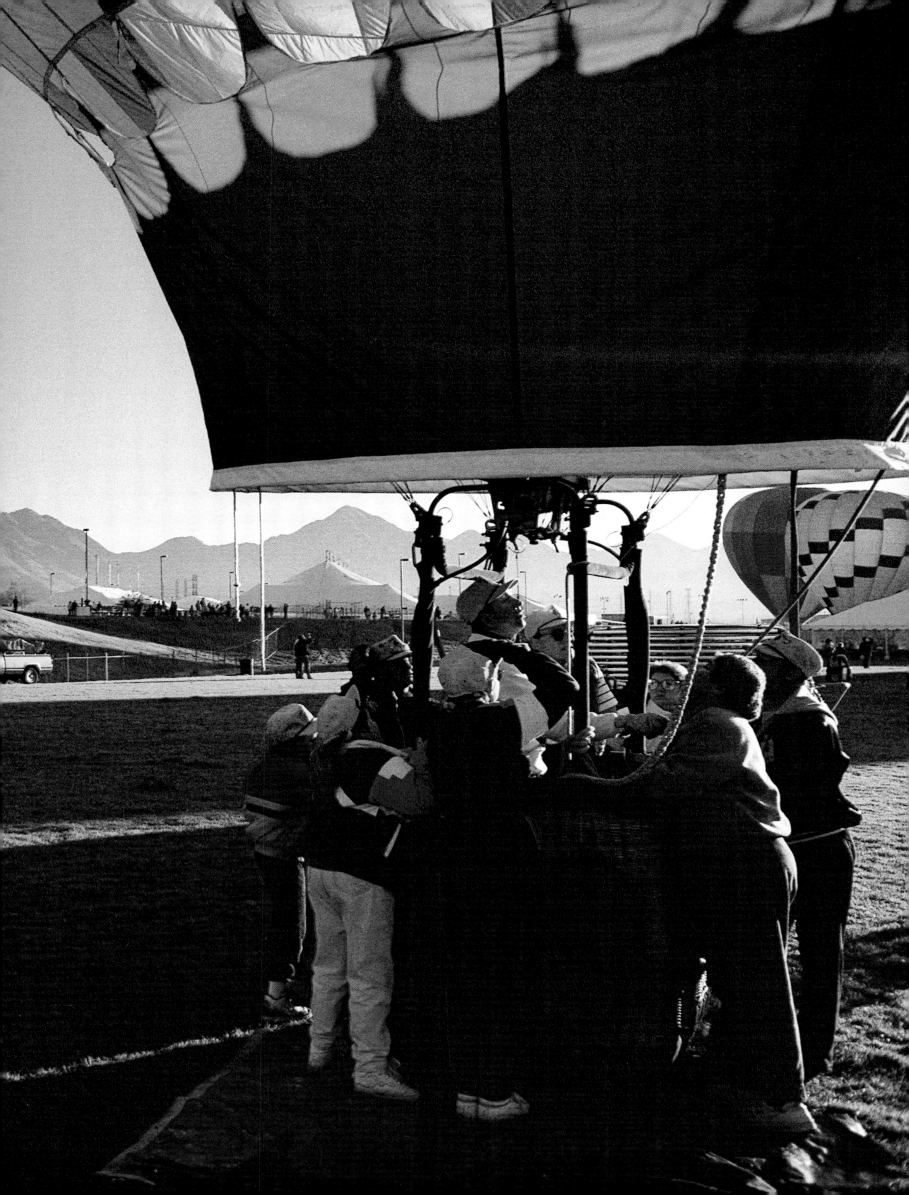

The Indian Bend Wash Greenbelt, with 1200 acres of park land, lakes and golf courses, stretches lengthwise through the heart of Scottsdale. Providing a unique combination of flood control and recreational amenities, it is an outstanding model for communities across the country.

Yet, in the early sixties, the U.S. Corps of Engineers planned to build, instead, a seven-mile long, 172-foot wide, wire-fenced concrete channel to carry the ravaging floods that periodically flowed through the normally dry, dusty wash. A few citizens suggested a grassy flood plain as an alternative. I was at that time a new Scottsdale resident, and as a landscape architect, I presented a comprehensive plan to make the entire wash a "greenbelt" tying the entire seven-plus-miles together in a Central Park atmosphere.

The city endorsed the concept, but soon discovered that the road to the beautiful greenbelt was filled with thorns. The federal administration stood firm in its support of the concrete channel. The city persisted, and a Comprehensive General Plan, adopted in 1966, suggested incentive zoning to encourage private landowners to participate. Finally, in 1970 the Corps of Engineers was willing to consider a partnership with the city to develop the Indian Bend Wash as a greenbelt.

Then, in June, 1972, a disastrous flood raged through Scottsdale. Many homes were damaged, and one person drowned. The need for flood control was never more dramatically evident. The following year the financing was secured. Over the next decade, what was once a wandering, inadequate flood plain became the completed scenic greenbelt we enjoy today.

The citizens of Scottsdale, seeing what could be accomplished, wanted this beauty expanded to all areas of the city. With this direction, the Councils implemented over the years street landscaping and architectural review, to ensure the superb quality of life that Scottsdale offers today.

Councilman Bill Walton

(opposite page)
Indian Bend Wash faithfully serves its purpose as a flood control basin, obliging golfers here to temporarily adjust their strategy.
(photo Michel F. Sarda)

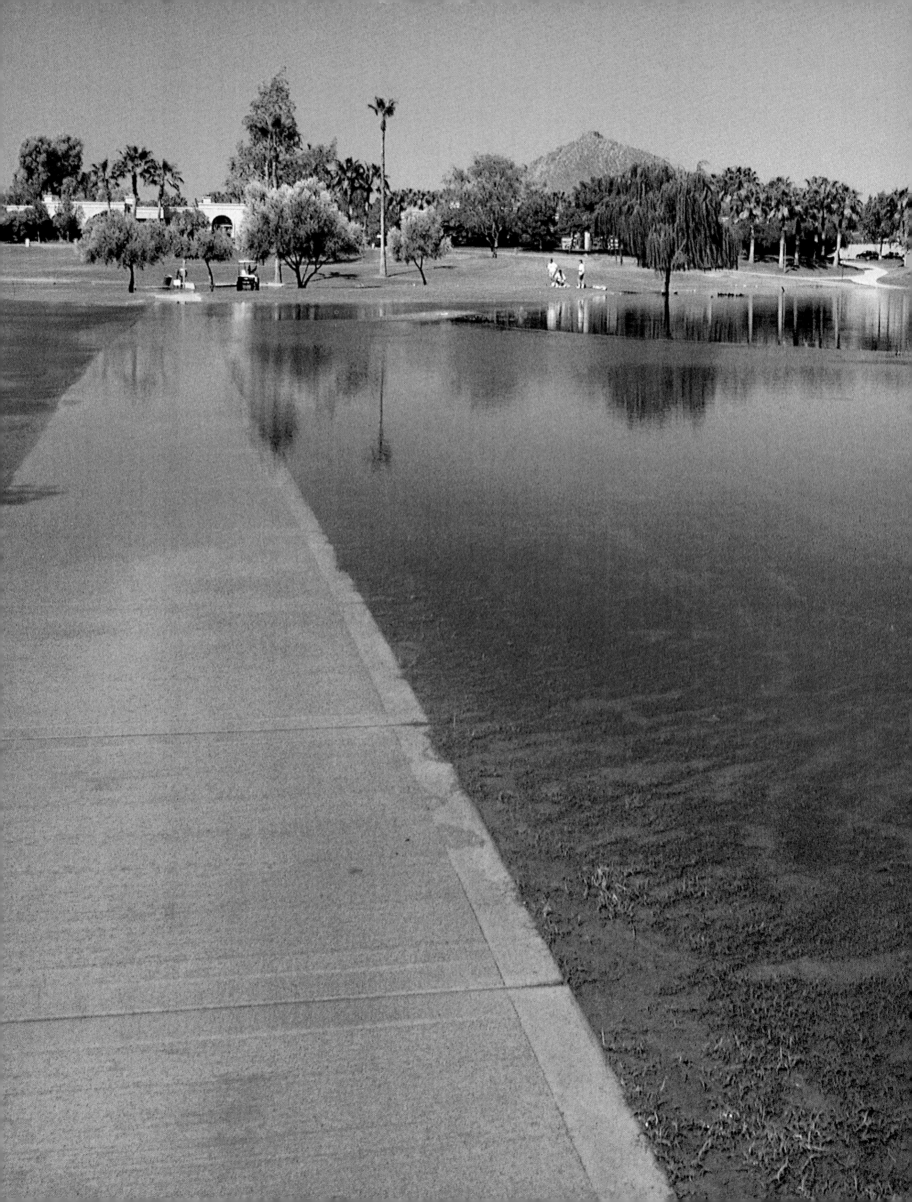

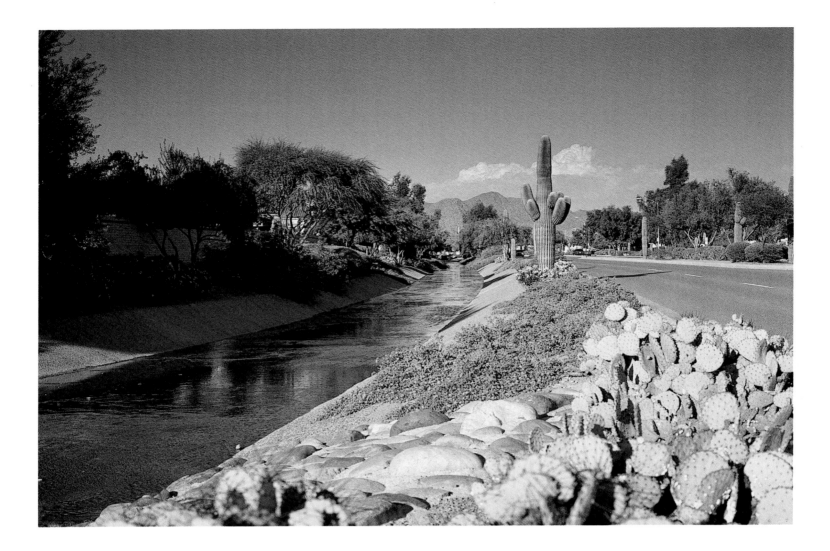

... Now the living water flows
Down broad canals, and where it goes
Tree-shaded homes dot fields of green
With fragrant orchards in between,
The arid waste, inert so long,
Awakes to give a desert song.

Irene W. Grissom

Street landscaping on Via Linda illustrates environ-
mental care and concern.
(photo Michel F. Sarda)

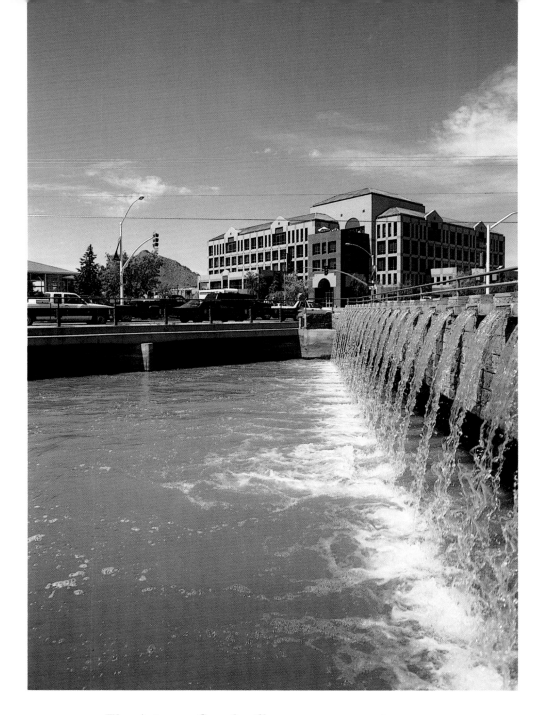

The Arizona Canal will emerge as a major water attraction in downtown Scottsdale with a system of lush paseos integrated with shops, restaurants and day and night entertainment.

Environmentally sensitive design will provide an oasis with year-round outdoor comfort. Extensive use of public art will greatly improve the function and aesthetics of the Canal.

A visual awakening will occur with public spaces featuring landscaping, special seating, lighting, water features and public art, establishing the area as a pedestrian's dream. Visitors will find new ways to experience our desert, while Scottsdale residents will appreciate the new-found exposure to water in our arid southwest.

William P. Schrader, Salt River Project
Former Mayor of Scottsdale

Arizona Canal at the crossing of Camelback and Scottsdale Roads.

(photo Michel F. Sarda)

(photo Bill Timmerman)

Mayo Clinic Scottsdale –
carrying on a 100-year tradition.

Mayo today embodies the values and
vision of its founders, William and Charles
Mayo. The two country doctors shared
their father's passion for medicine,
teamwork, innovation and service to
humanity.

Over a century ago, the Mayo brothers,
together with their father, formed a family
group practice in the farming community
of Rochester, Minnesota. William and
Charles Mayo were progressive, always
seeking to learn new techniques and creating
their own. Their primary goal, however,
was compassionate patient care of the
highest standard.

This is the Mayo health care system.
And, as Mayo Clinic Scottsdale brings its
unique practice of medicine, education and
research to the Southwest, our primary
goals remain unchanged.

Dr. Richard Hill
Mayo Clinic Scottsdale

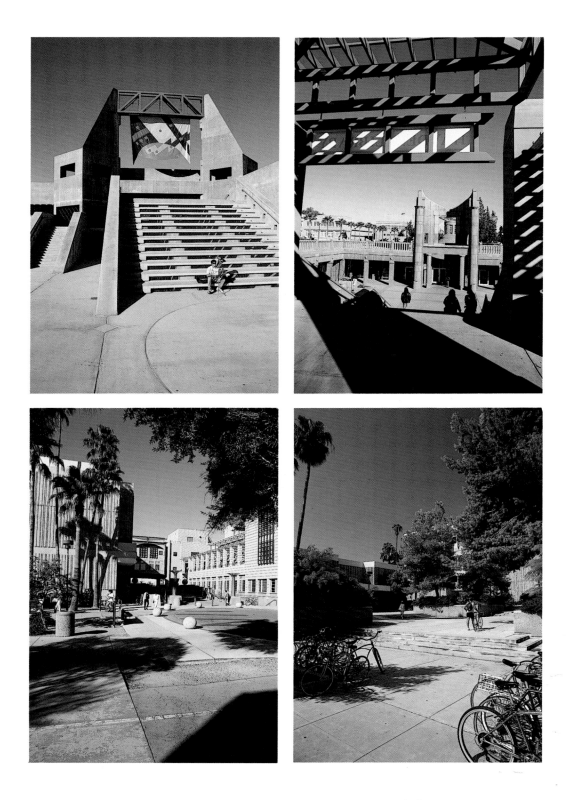

Scottsdale benefits from the immediate vicinity of
Arizona State University – one of the largest in the
United States. An ambitious development program
brings a stream of state-of-the-art new facilities.
Clockwise from top left:
– The Nelson Art Center.
– The Hayden Library and its recessed patio.
– The Arts Building.
– The College of Architecture & Environmental
 Design.

(photos Michel F. Sarda)

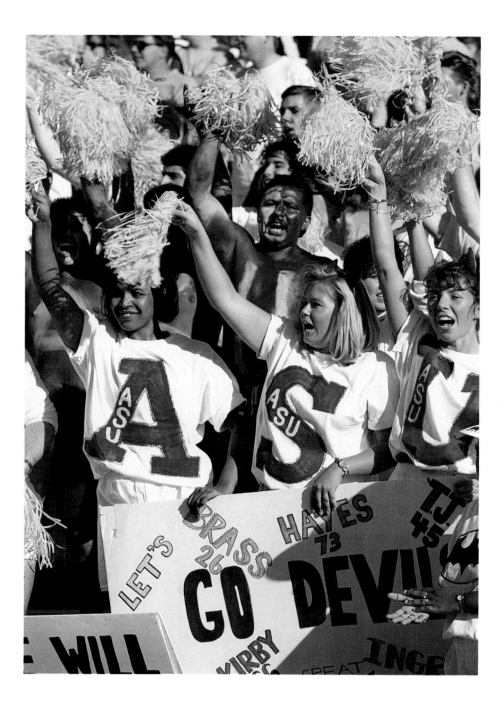

ASU students support their football team whole-
heartedly.

(photo Michael Mertz)

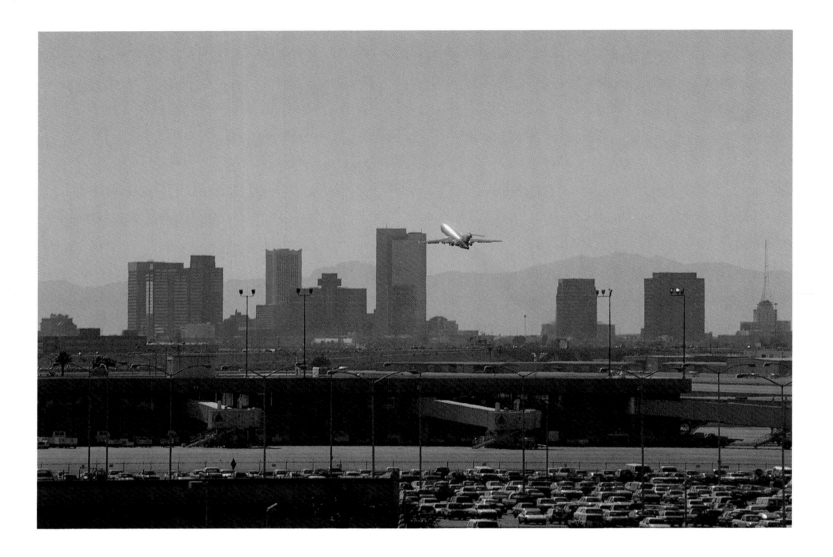

(above)
**Sky Harbor International Airport connects the
Valley of the Sun to the entire country and beyond.
It has become one of the fastest-growing airports .**

(opposite page)
**The skyline of adjacent Phoenix suggests a distant
world to Scottsdale residents.**
(photos Michel F. Sarda)

We gathered all the sunlight
Spangled into day
And heard the cloud of tumult
Driven far away.

Patricia Benton

Lifestyle

Those of us who grew up in Scottsdale, never stray too far. Because of its wonderful weather, recreational activities, diverse cultural programs and many enriching experiences, our town is a place that we don't want to leave, and one that continues to attract new residents and visitors alike.

Scottsdale maintains its unique western flavor, while simultaneously playing host to emerging technologies. Businesses continually arrive here and educational opportunities continue to expand, attracting students from all over the world. New retail centers are springing up around the city, as existing ones brighten for the decade ahead. It's a place for families and single persons, cowboys and CEOs, the young and the not-so-young, all wrapped in southwestern warmth and hospitality.

That's why many of us never stray far; and, those who do, always return to Scottsdale!

Councilman Susan Bitter Smith

Gold of earth and gold of trees
Flaunting golden harmonies:
All this treasure gathered up
Held within a burnished cup
Where the heaven's light and thunder
Fills the brimming heart with wonder
And the light, unfettered stream
Fringes fields of golden dream.

Patricia Benton

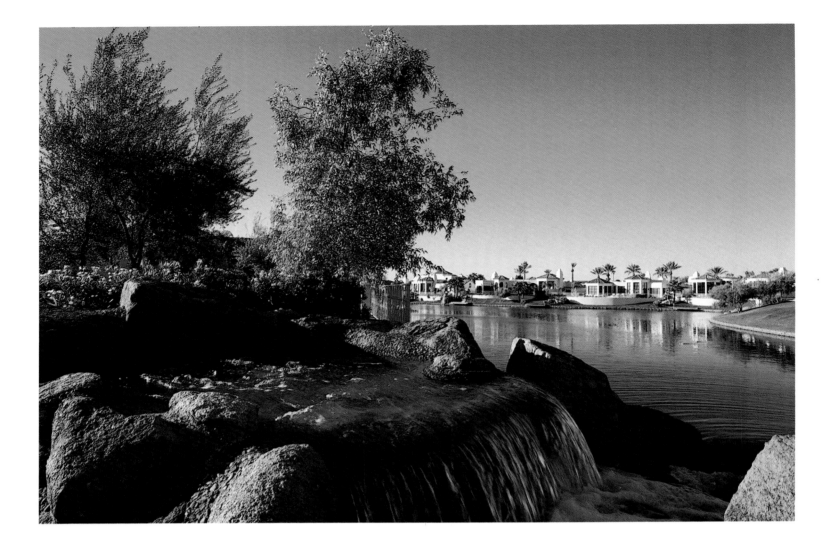

So in some desert-place of life,
Where drought prevails, and storms are rife,
Some healing fountain, hid from sight,
Some radiant sun of love and light,
Some potent sovereign of the hour,
Asserts its strange, mysterious power —
Repeats the miracle of spring,
And sets the desert blossoming.

Anonymous

(above and opposite page)
Lakes add coolness and visual enjoyment to many
residential developments.
(photos Alan Benoit & Michel F. Sarda)

Barren and dormant a desert lies,
Far from the peak where rivers rise,
Tomorrow it shall be green and fair
When men of vision bring water there …

Irene W. Grissom

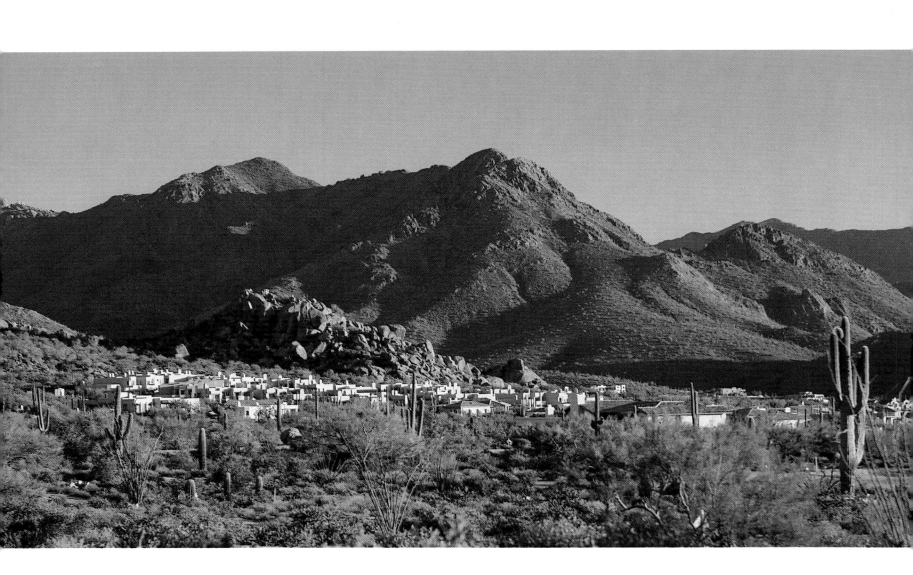

Here was peace in the stillness,
Here was joy in the sun ...

Sharlot M. Hall

(above)
Troon Village is nestled in the mountain range of northern Scottsdale.

(opposite page)
Stunningly beautiful homesites call for innovative design. This one was inspired by thousand-year old masonry techniques of the Anasazi – *The Ancient Ones* – Arizona's early native inhabitants.

(photos Michel F. Sarda)

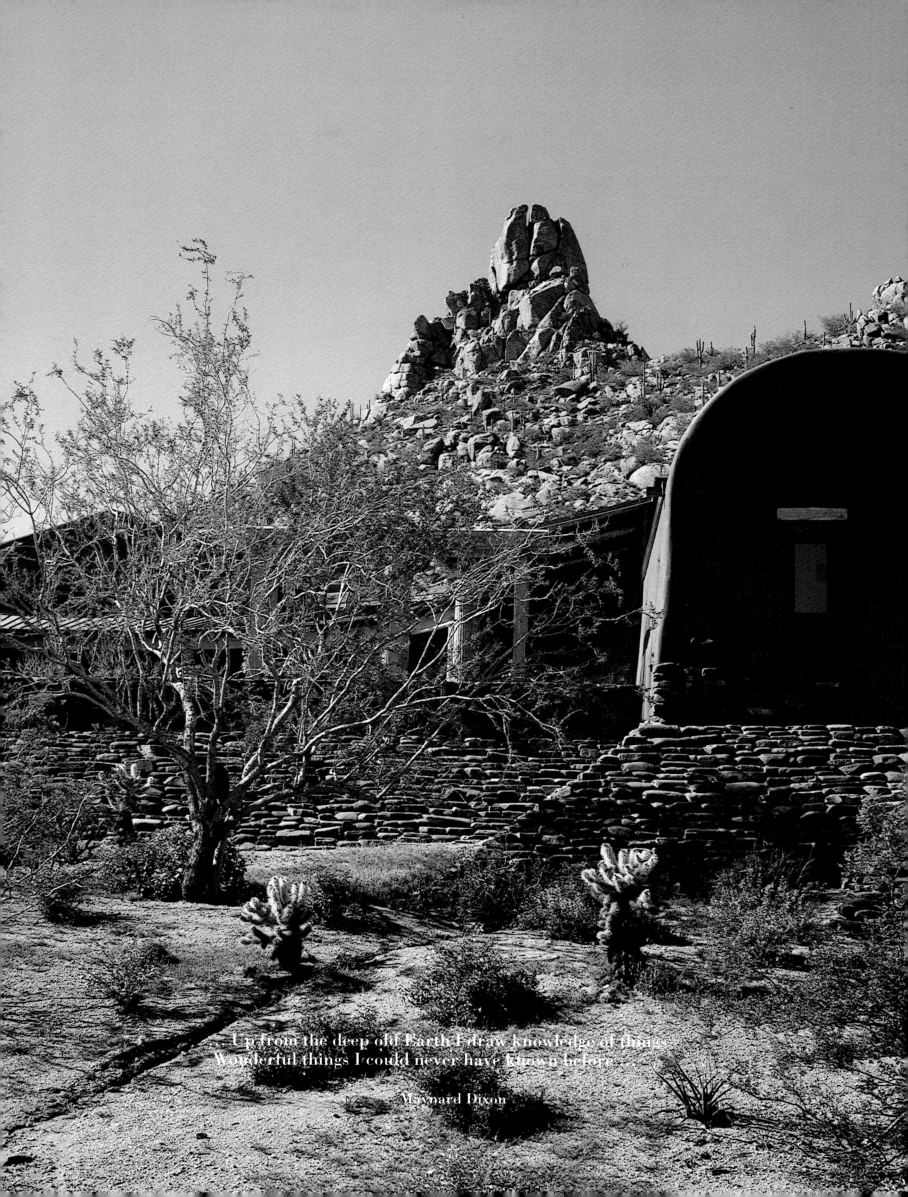

... Up from the deep old Earth I draw knowledge of things
Wonderful things I could never have known before ...

Maynard Dixon

(above and opposite page)
**Swimming pools are extensions of the living rooms
most of the year.**
(photos Michel F. Sarda)

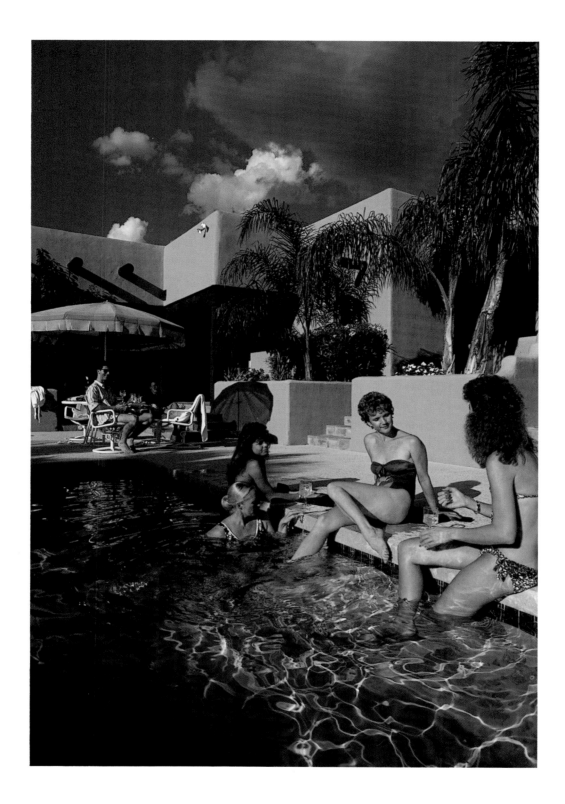

The mind
A sheath greengold
On a pool
Quivers
As the shadow of a cloud
Touching the fields, unfurls
A lazy wave of air ...

Harry Behn

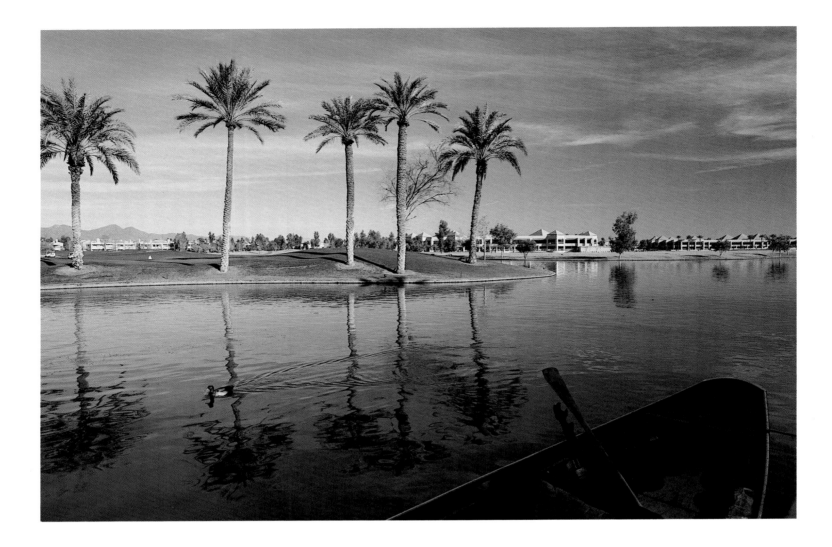

The Builder

Placing together stone on stone
He shapes a rampart all his own.

Under domain of familiar skies
He holds blue kingdoms in his eyes.

Patricia Benton

(above and opposite page)
Business centers offer a resort-like environment.
Above, Gainey Ranch Corporate Center. On the
right, the Chase Bank headquarters on McCormick
Lake.

(photos Michel F. Sarda)

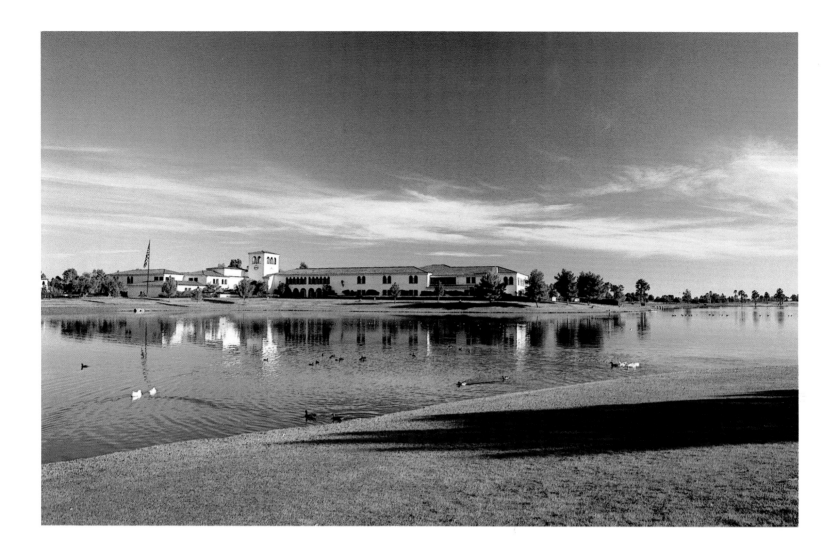

Nothing sweeter in the desert
 Than the blessed water's kiss,
Not the cool wind's coming, even,
 With its soft, caressing bliss.

J. William Lloyd

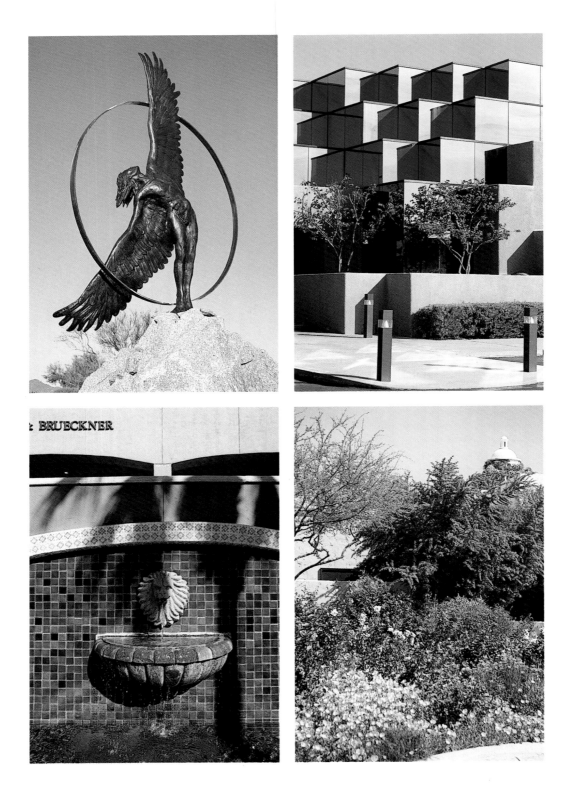

Tasteful creativity and diversity characterize the surroundings of Scottsdale's business environment. Clockwise, from top left:
– *One-with-the-Eagle*, by artist Pat Mathiesen, signals the access to Scottsdale Municipal Airport.
– Evergreen Corp. building at Scottsdale Airpark.
– Oaxaca, near Pinnacle Peak.
– Fountain in a courtyard of The Scottsdale Center.
(photos Michel F. Sarda)

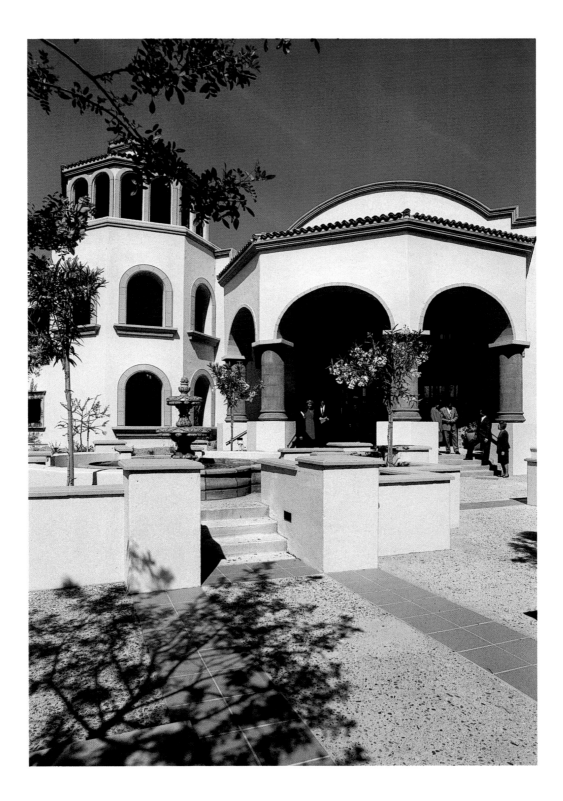

The new Giant Industries headquarters epitomizes
Scottsdale's convivial corporate philosophy.
(photo Michel F. Sarda)

Somebody said that it couldn't be done
 But he with a chuckle replied
That "maybe it couldn't," but he would be one
 Who wouldn't say so till he tried.
So he buckled right in with the trace of a grin
 On his face. If he worried he hid it.
He started to sing as he tackled the thing
 That couldn't be done, and he did it.

Edgar A. Guest

A variety of Scottsdale's commercial signs.

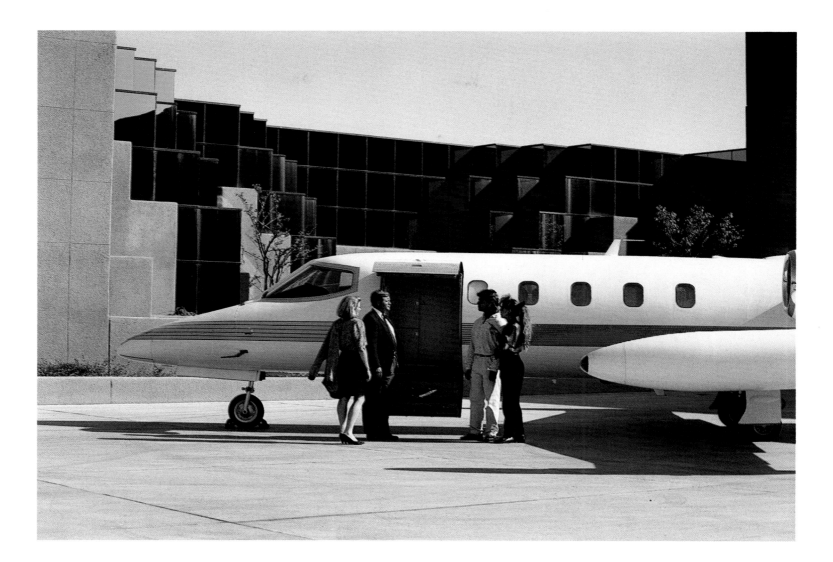

The concrete and steel runways and hangars of the former World War II flight school are now the heart of a bustling business environment. Like the center of a giant propeller, the Scottsdale Airport serves as the hub to the Scottsdale Airpark.

Beyond the unique convenience of having one's company plane steps away, a synergy animates the airpark, sparked by the thousands who work here. At the geographical center of Scottsdale, businesses and customers are attracted here as much out of desire as necessity.

The intimacy of this municipal airport makes the complex a very personal place, and an integral part of the Scottsdale community.

Russell Allen
Corporate Jets

Scottsdale Airpark offers the possibility to keep a plane within walking distance of the office.
(photo Michel F. Sarda)

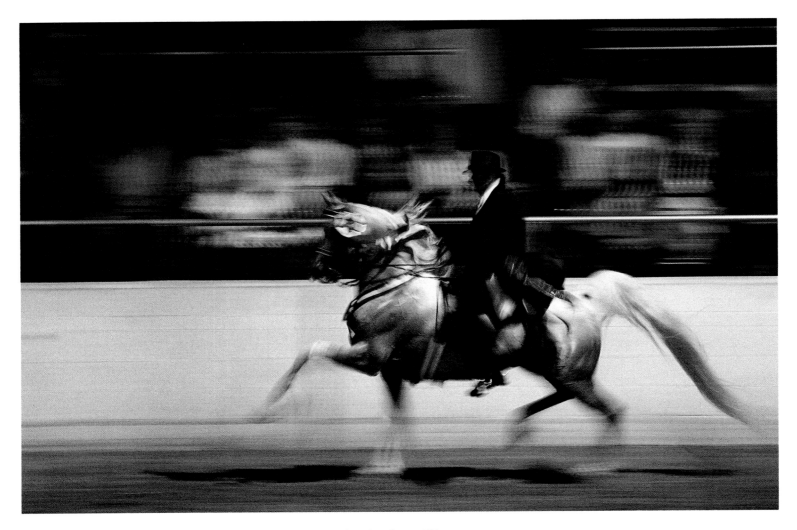

The Arabian Horse

The legends of the Arabian horse are inextricably intertwined with the truth – but what less can be expected of a two thousand-year-old legacy?

Bedouin legend has it that God "took a handful of southerly wind, blew His breath across it and created the horse." And indeed, the Bedouins called their fiery steeds "Drinkers of the Wind" for their ability to carry their masters long distances across the desert, fight fiercely in battle, then carry them swiftly and safely home.

In the Koran it is written that God wove virtue into the forelock of the Arabian and clothed his neck with thunder. Small wonder the Arabian was the war horse and companion of generals like Alexander, Napoleon and Lee. Catherine the Great is depicted in art mounted upon her Arabian, and President Grant is immortalized in statues riding his favorite Arabian stallion.

Today, the Arabian is referred to as "Living Art" for their finely chiseled heads, porcelain coats and gossamer, high-flung tails. They are collected by movie and sports stars, giants of business and industry.

But the true beauty of the Arabian is found in his kind eyes; the gentle way he carries a child upon his back; and the ability to make us feel like a king – like a part of a legend – when we are in his presence.

Misdee Furey
(Text dedicated to her mother, Dee Dee Wrigley)

This Arabian horse parades at the annual All-Arabian Horse Show.
(photo Alan Benoit)

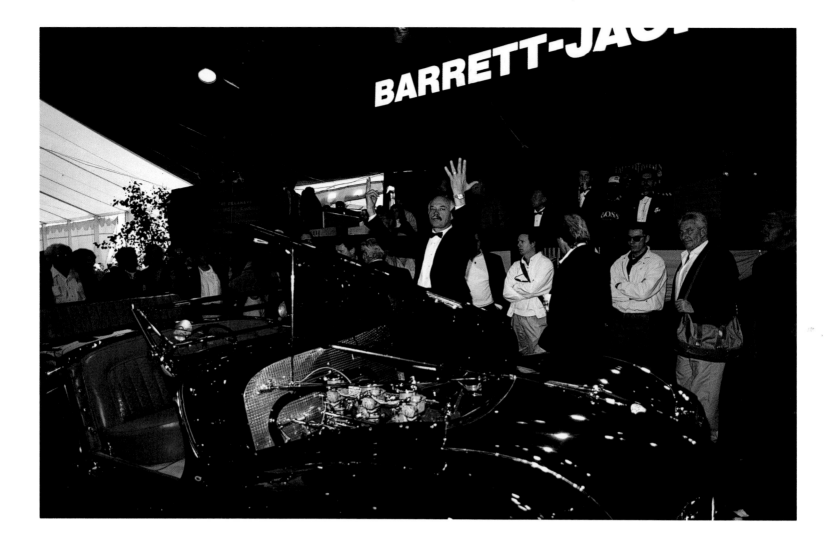

The Barrett-Jackson Auto Classic auction sale, the
largest in the world for vintage cars, is held here at
WestWorld.

(photo Alan Benoit)

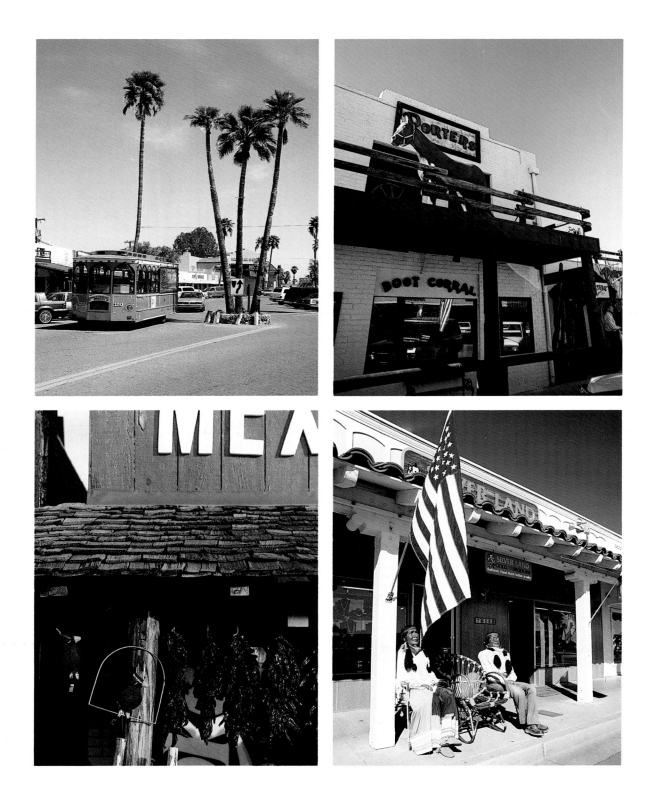

Shopping in Old Scottsdale is a visual experience.
Clockwise from top left:
– The Poney Express trolley on Fifth Avenue
– Porter's shop on Brown Avenue
– Two popular residents of Fifth Avenue
– Mexican Imports on Brown Avenue, one of the
oldest shops in Scottsdale.
 (photos Michel F. Sarda)

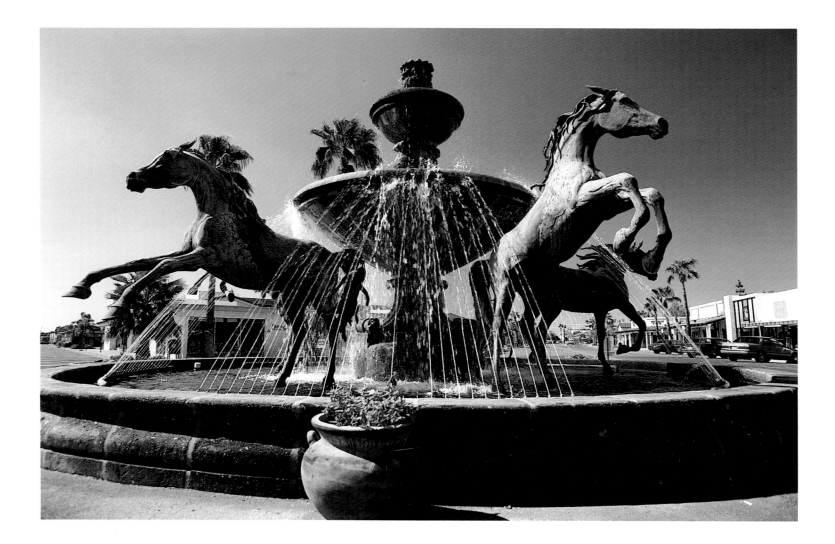

A horse is a thing of such beauty... none will tire of looking at him as long as he displays himself in his splendor.

Xenophon

These bronze horses, emerging from the Fifth Avenue fountain, were donated to the City by artist Bob Parks.

(photo Michel F. Sarda)

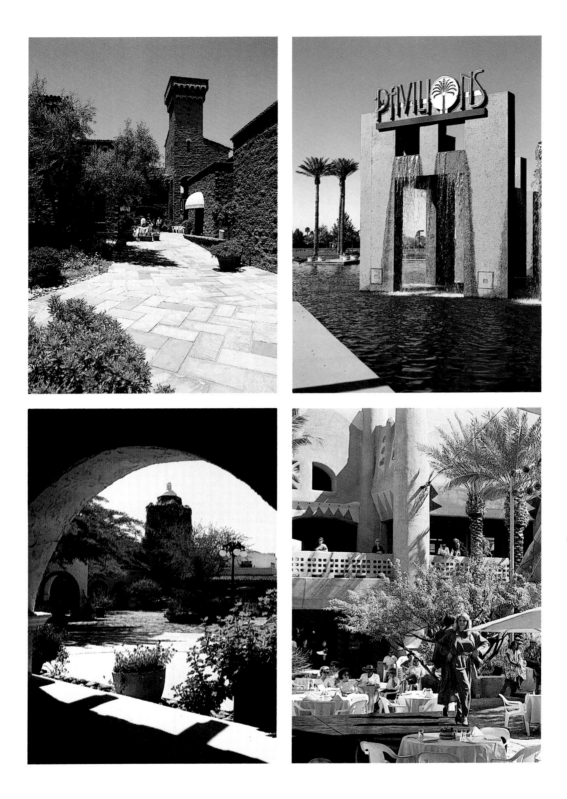

Shopping around town is nothing conventional.
Clockwise from top left:
– The Borgata
– The Pavilions
– Fashion show at El Pedregal
– Oaxaca at Pinnacle Peak
 (photos Michel F. Sarda)

**Papago Plaza is a colorful reminiscence of the old
territorial style.**
(photo Michel F. Sarda)

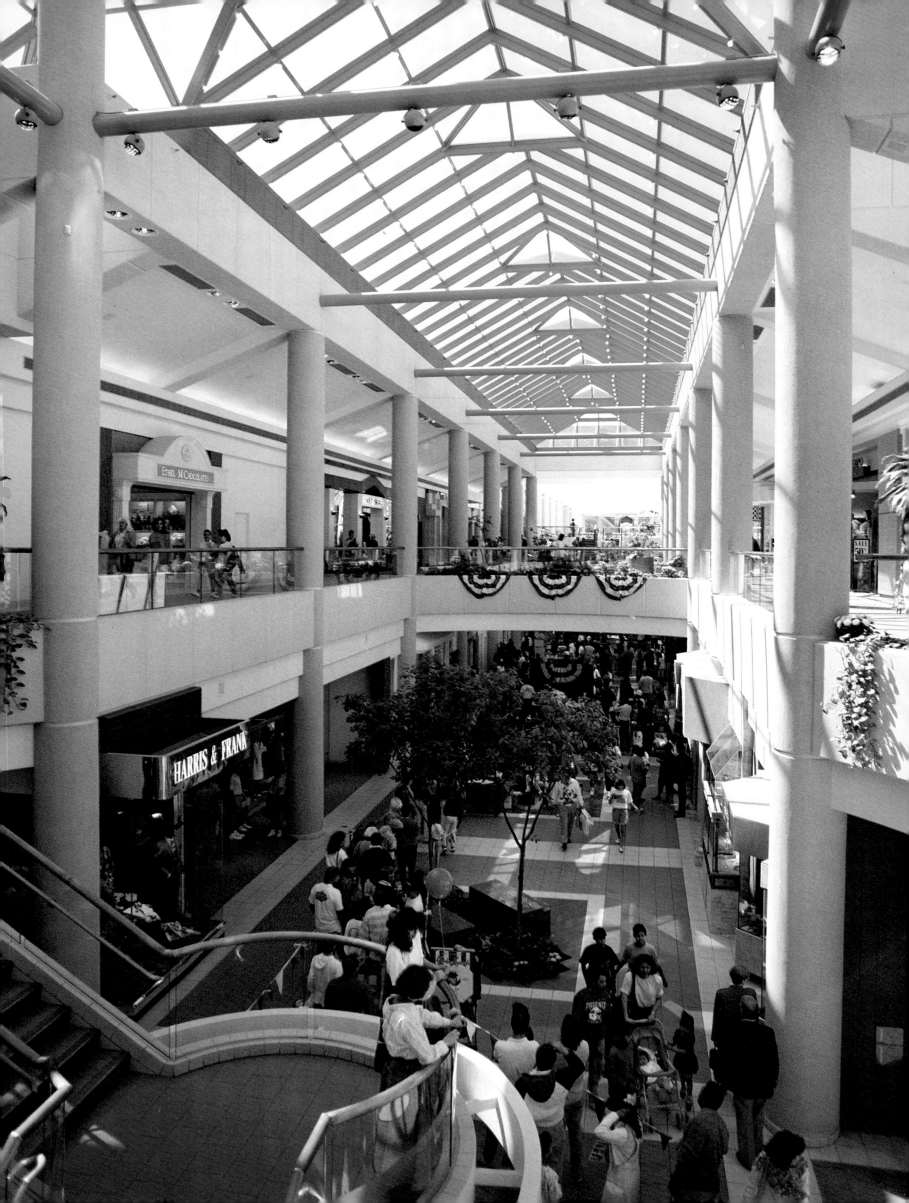

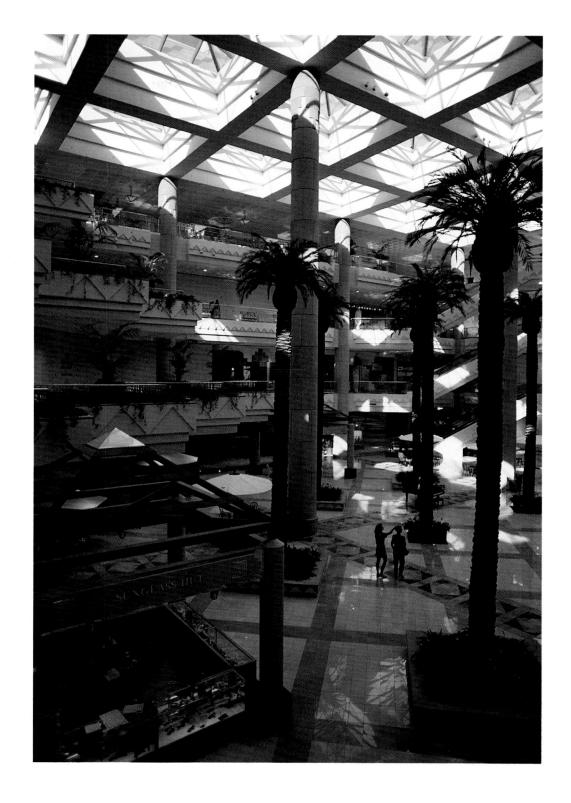

(above)
The Scottsdale Galleria is a cathedral-sized shopping heaven.

(opposite page)
Scottsdale Fashion Square has been expanded to become one of the largest shopping malls in the Valley.

(photos Michel F. Sarda)

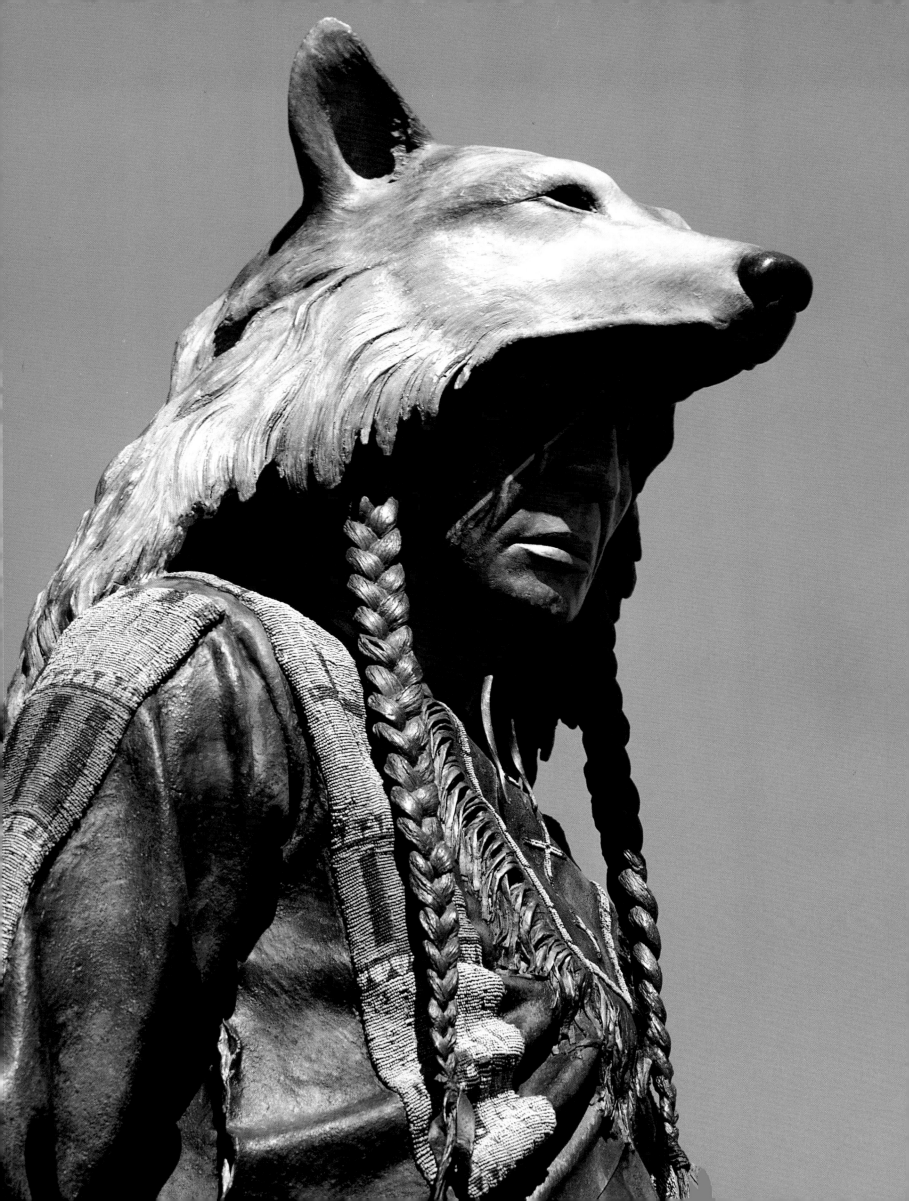

Scottsdale has long been a mecca for creative people, both artists and craftsmen. And where artists go, art galleries follow.

Now the home to many prominent, internationally-known artists, Scottsdale has established itself as one of America's important fine arts centers, with more than eighty fine arts galleries. The types and styles of art work represented here run the gamut from the *avant-garde* contemporary to the traditional representational and western.

With creative flair, the art community continuously generates appealing events, such as the Festival of the Arts, Best of Scottsdale, and the popular Thursday Night Art Walk. Scottsdale will continue to grow in importance and earn the reputation of the premier art center in the West.

Stephanie Roberts
Scottsdale Gallery Association

(above)
The Thursday Night Art Walk is a favorite destination for Valley residents and winter visitors.
(opposite page)
Rain-in-the-Face, a life-size polychrome bronze by southwestern artist Dave McGary, is a stunning example of the western art which attracts collectors from all over the world.
(photos Michel F. Sarda)

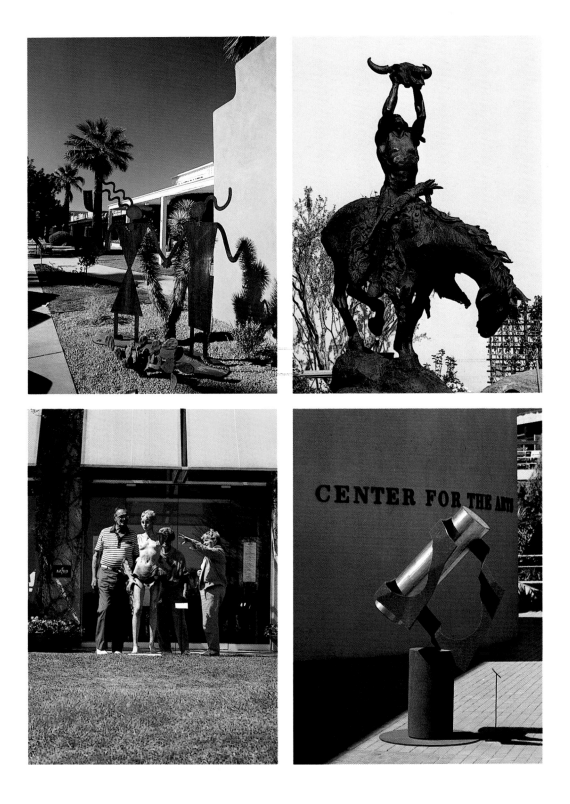

Clockwise from top left:
– The arts are an unmistakable part of the town's street scenes – here on Main Street.
– *Invocation*, the 15-foot-tall bronze monument by Buck McCain, reminds north Scottsdale shoppers of the Native American heritage.
– *Abstract Wrap*, by James Mitchell, illustrates contemporary trends at the Center for the Arts.
– Intrigued visitors exchange views on *Barefoot and Fragmented*, by Nick Moffelt, one of the exhibits of the Best of Scottsdale outdoors art presentation.
(photos Michel F. Sarda)

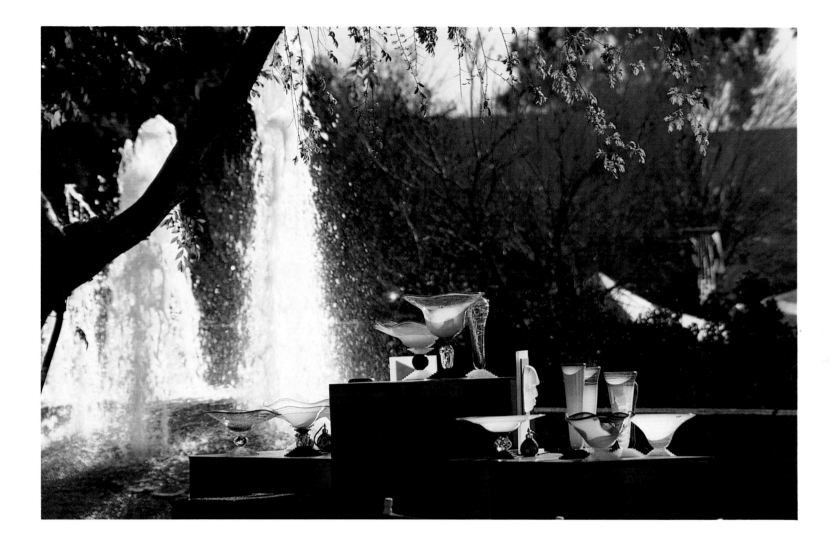

Glassware is displayed at the annual Arts Festival.
(photo Michel F. Sarda)

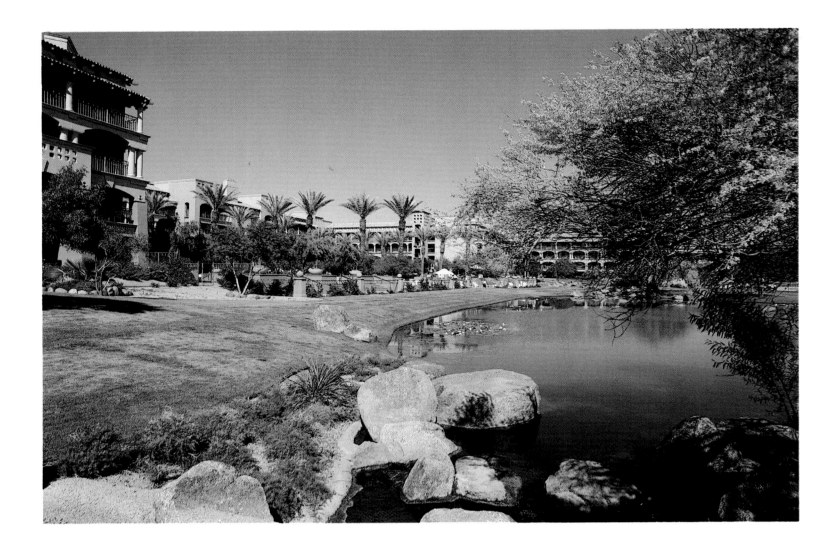

... Lock this turquoise hour
In the coffer of memory.

Patricia Benton

(above)
The resorts of Scottsdale rival each other in elegance
and luxury. Here, the Scottsdale Princess.
(opposite page)
The spectacular waterfall of the Scottsdale Princess.
(photos Michel F. Sarda)

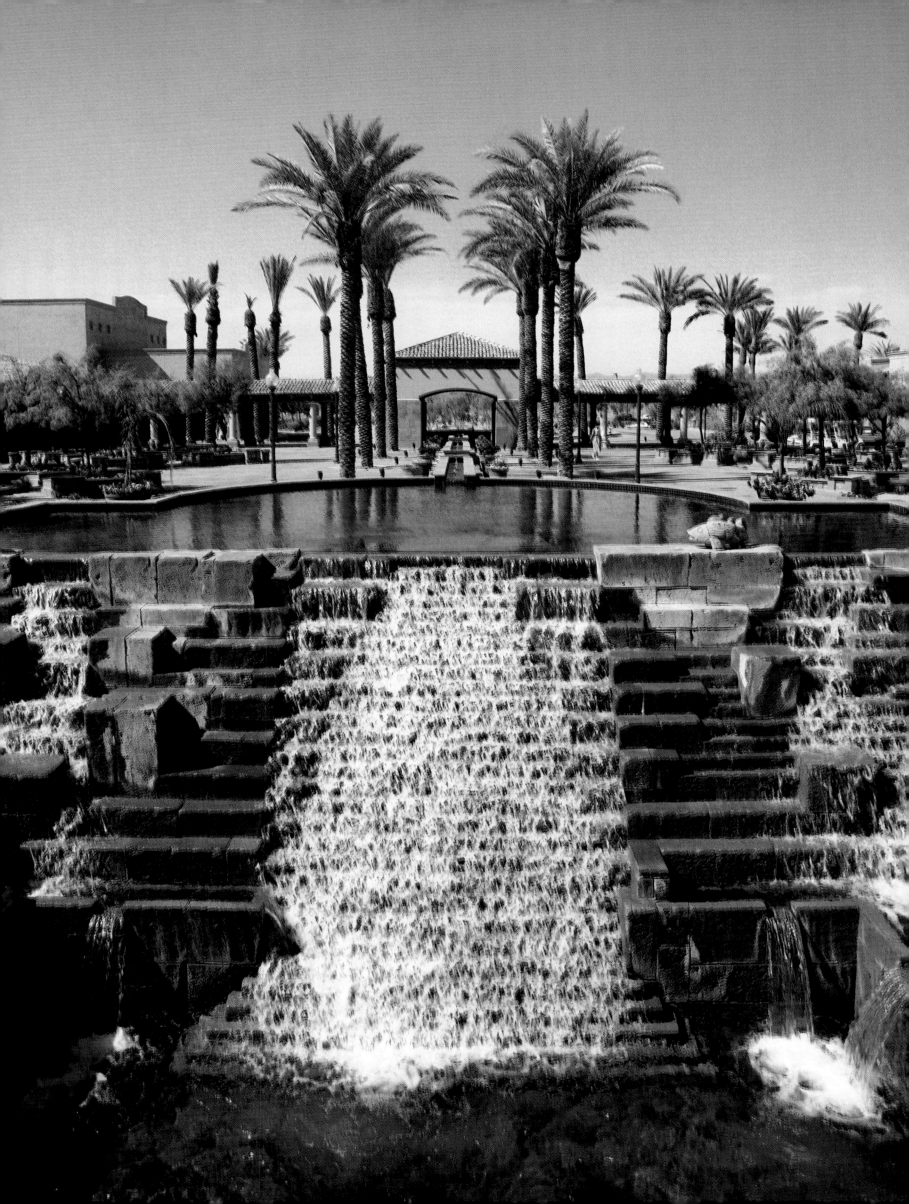

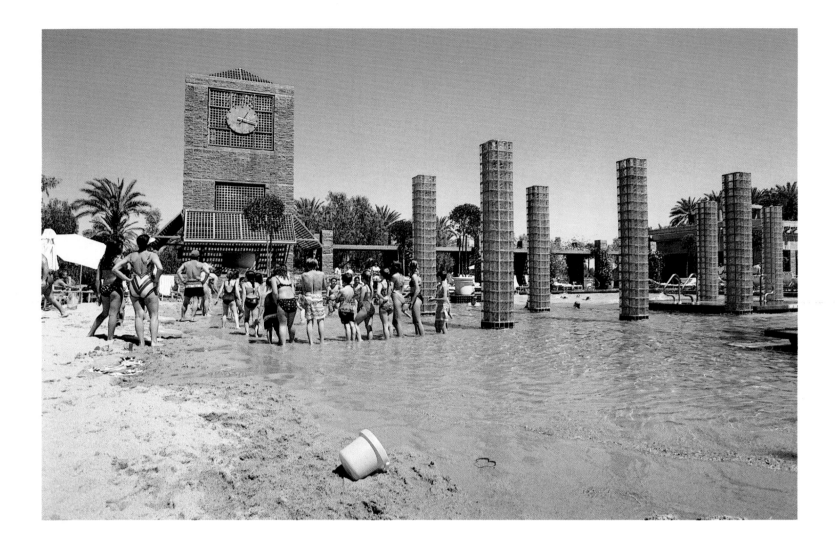

(above)
The swimming pool of the Hyatt Regency Scottsdale features a sand beach.

(opposite page)
On the grounds of this same resort, the inviting Golden Swan has been recognized by a leading travel magazine as an "outstanding restaurant."

(photos Michel F. Sarda)

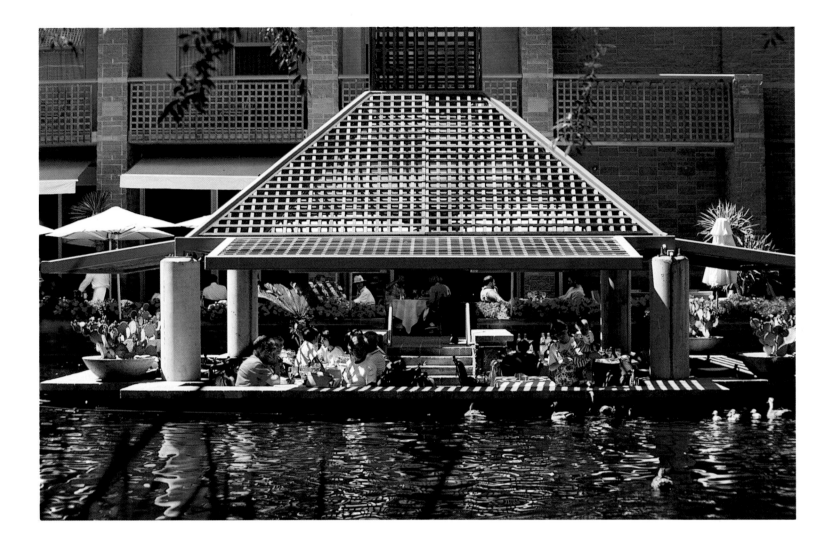

… Land of sunshine and birds and flowers,
Where Time himself notes not the hours

But flings his scythe and glass away
To dream, in your beauty, the live-long day.

Sharlot M. Hall

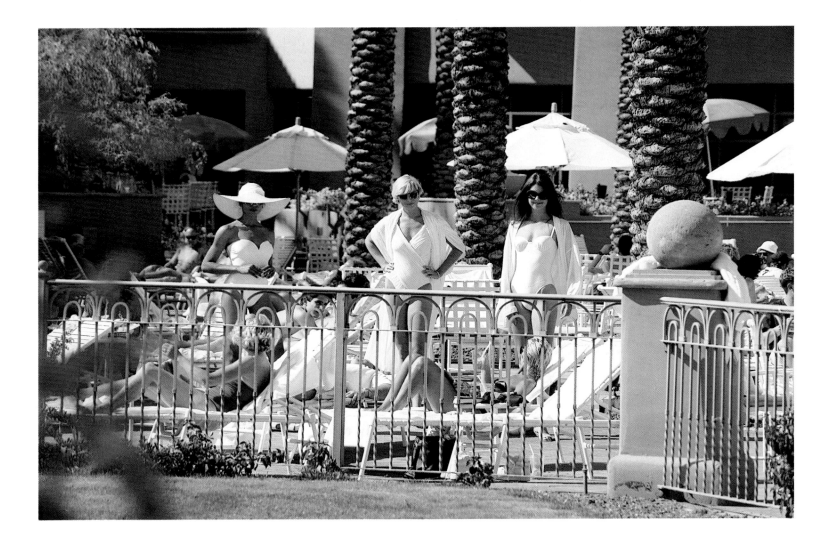

(above)
Informal modeling adds to the enjoyment at the swimming pool of the Scottsdale Princess.
(opposite page)
Camelback Mountain towers above The Phoenician Resort.

(photos Michel F. Sarda)

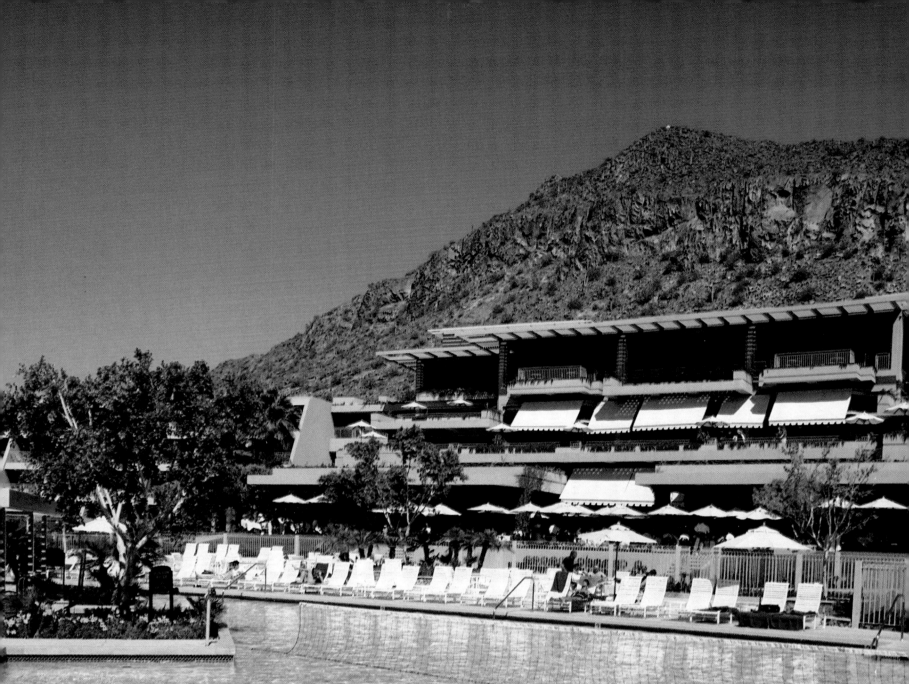

High as the air soars
In its flight
A wall of heat haze
Folds the earth.
Trees, floating in sunlight, sway,
Water drips in delight,
Monotony
Drums cadences upon the wind;
… Mind sprawling
On the pool of Time,
Time rippling away
To forgetfulness.

Harry Behn

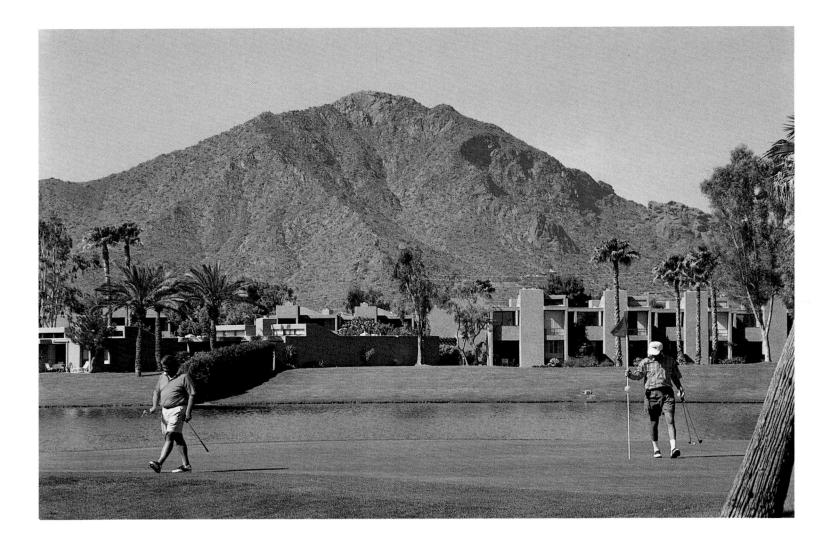

With dozens of top-rated golf courses, Scottsdale
has become in recent years one of the world's capitals
of golf. Here, the McCormick Ranch Golf Club,
with Camelback Mountain in the background.
(photo Michel F. Sarda)

The clubhouse at Desert Highlands offers striking
views. It was rated in 1990 among the most beautiful
in existence.

(photo Michel F. Sarda)

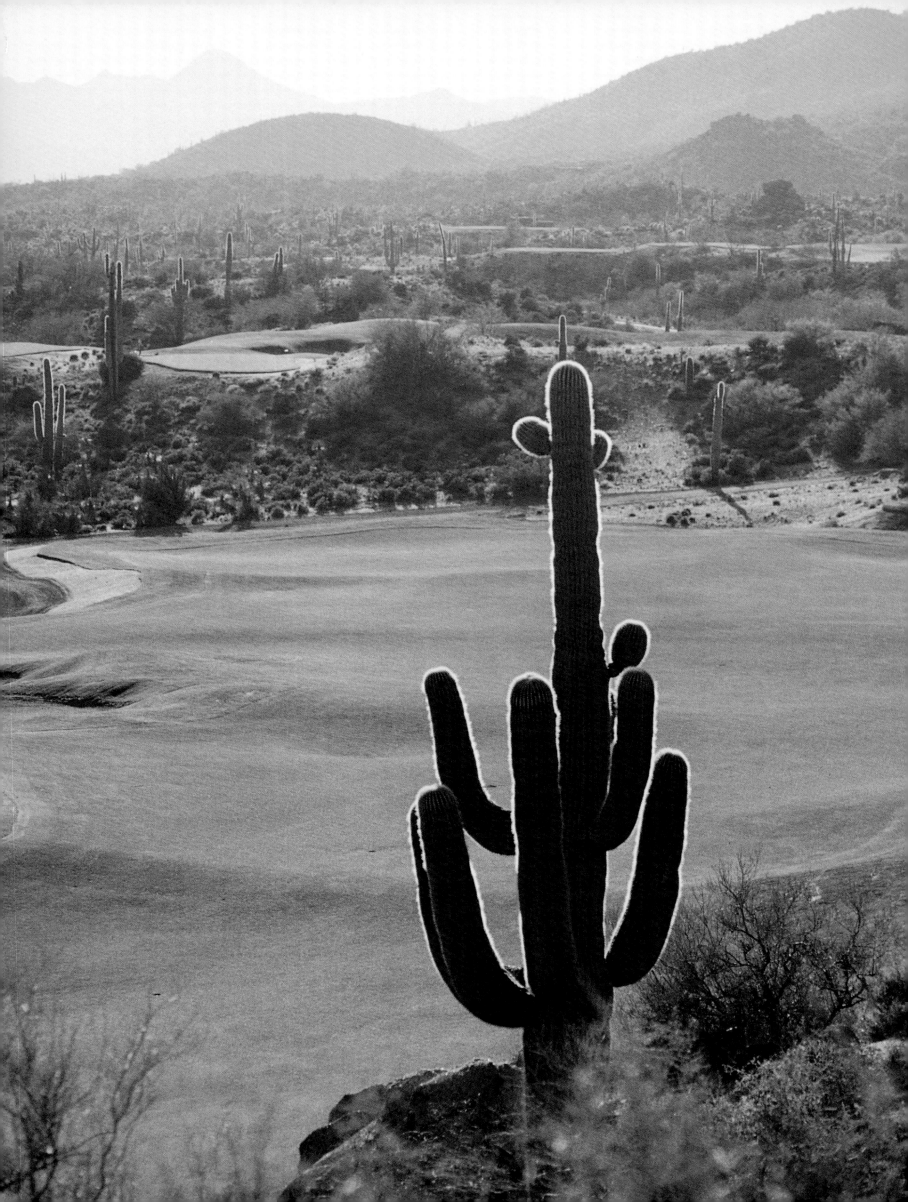

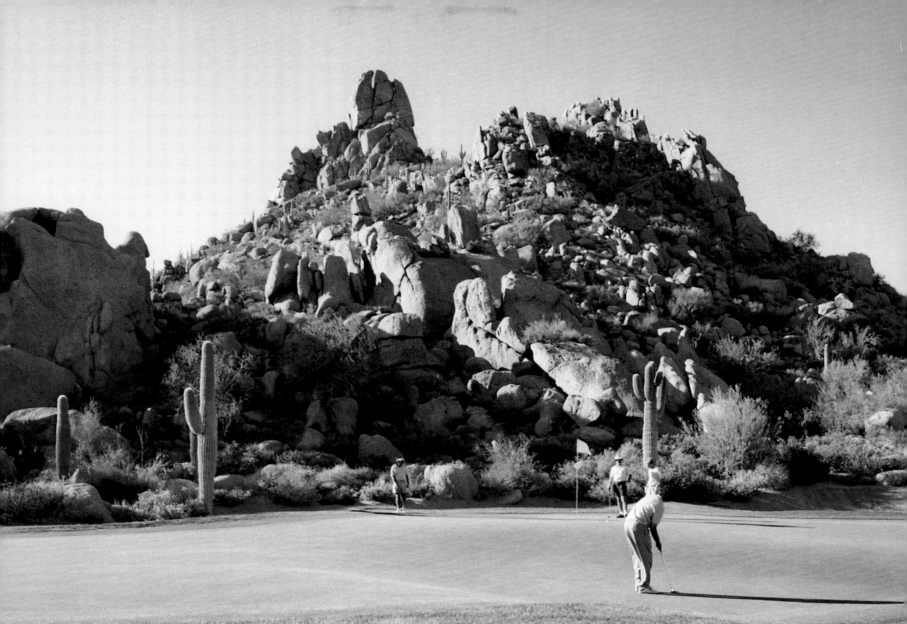

"When we designed the Desert Highlands golf course in the early 1980s, it took very careful planning to save the native vegetation and to provide for revegetation. We installed an elaborate irrigation and drainage system. No golf course in the desert had ever gone to such lengths to preserve the natural scene.

"...some holes have outstanding rock outcroppings or gorges to play over. There are some with water, and some that have great mountain views. There's such a diversity.

"As a matter of fact, because the desert is usually very dry and the ball travels higher and farther, you'll probably find that playing golf in the desert is easier. If not – well, just relax and enjoy the beautiful scenery."

Jack Nicklaus

(above)
Pinnacle Peak dominates the 15th green at Desert Highlands Golf Course.
(opposite page)
The golf courses at Desert Mountain, also designed by Jack Nicklaus, blend into the desert terrain.
(photos Michel F. Sarda)

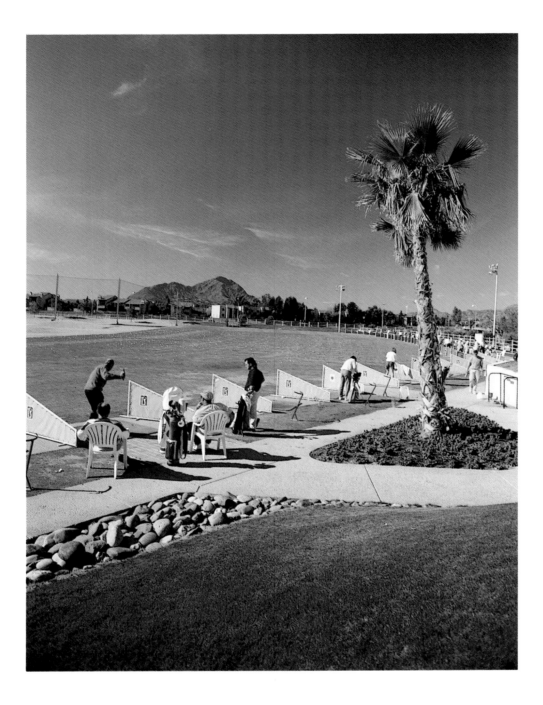

**Golf enthusiasts make practicing their swings a part
of their everyday life.**
(photo Michel F. Sarda)

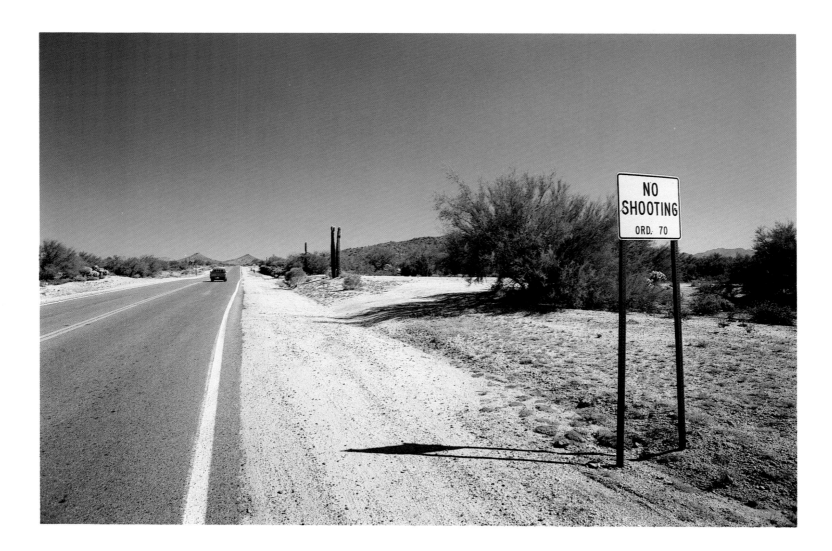

Who travel desert roads are restless men
That wander far to seek adventure's gain,
And come and go across the windswept place
As shadows pass and vanish into space.

Irene W. Grissom

Society tames the outspoken West.
(photo Michel F. Sarda)

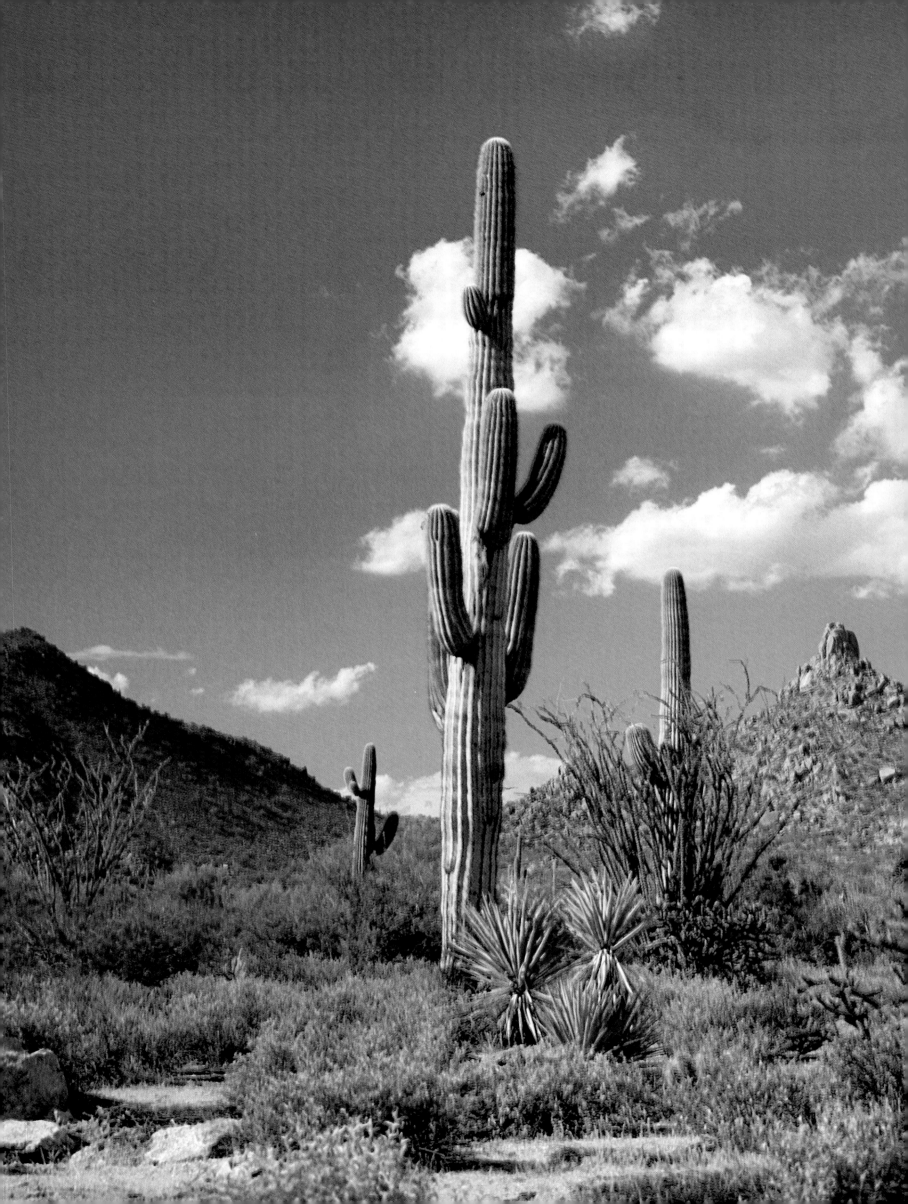

The Sonoran Desert

space silence strength
< contrasts >
interlocking interdependent
harsh, gentle, spectacular, delicate, ageless
vulnerable

slow growing saguaros as at home as
wildflowers with their compressed lifespan counted in hours

nothing stays the same
crystals grow
rocks erode
people and plants develop - each at their own pace

So much yet to be discovered.

Florence Nelson

Listen and hear vibrant hooves
beating the distance as a thousand drums
calling those to follow
who dare the pinnacle
summoned by secret stars...

Patricia Benton

Unmatched beauty and diversity, conscientious and loyal to those who hold steadfast to its distinctive heritage: Scottsdale, "The West's Most Western Town," and the horse, have grown symbolically together, bringing life and definition to the way our city began and continues its graceful rise from the desert floor.

In the blowing wind, the soul of today's Scottsdale cowboy is revived to don boots and hat in search of the meaning of the Old West. If one listens to the wind in the McDowells, it carries a message as important today as when it echoed in the Valley over 100 years ago; trust and follow the intuitive lead of the team which so gracefully and poignantly sculpted our city's image.

The bond once shared between horse and rider during the settling years of Scottsdale was born of an unspoken relationship, revealing a team whose communication flowed effortlessly in harmony and grace. The dust they stirred remained behind upon their passing. In it is contained a distinctively different heritage which makes Scottsdale the most unique city of the Southwest.

Howard Keim
WestWorld

(opposite page)
This bronze group of horses by artist Snell Johnson, represents an Arabian, a thoroughbred and a quarterhorse. It signals the entrance to WestWorld, and forcefully captures the spirit of Scottsdale.
(photo Michel F. Sarda)

Appendices

Translations
Spanish
French
German
Japanese

Selected bibliography

Index

Photographers

Note of the Publisher.

We hope these translations will facilitate the enjoyment of this book to our international readers. Unfortunately, in regard to the available space, it was not possible to accommodate the translation in four different languages of all the texts, tributes and quotations appearing throughout the publication.

Translations

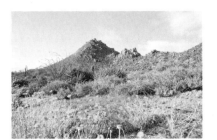

pages 18-19

Primero fue la tierra, el desierto sonorense.

A l'origine était la terre – le désert de Sonora.

Zuerst war das Land, die Wüste von Sonora.

ソノラン砂漠

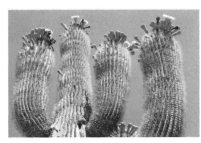

page 20

En la primavera las flores traen una inesperada sonrisa al gigante cactus sahuaro, curtido por la intemperie.

Au printemps, de la peau burinée du sahuaro, le cactus géant, surgissent des fleurs, comme un sourire.

Im Frühling bringen Blüten ein unerwartetes Lächeln auf die verwitterte Haut des riesigen Saguaro Kaktusses.

春になると風雨にさらされた大柱サボテンの肌に花が微笑みを誘う。

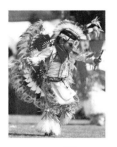

page 21

Las cultures Nativo-Americanas brindan gracia y armonía. Un niño Návajo de 5 años danza en el PowWow Anual de Scottsdale.

Les traditions indiennes apportent leur part de grâce et d'harmonie. Un enfant Navajo de cinq ans danse au Pow Wow annuel de Scottsdale.

Frühe amerikanische Kulturen tragen Würde und Harmonie bei. Ein fünfjähriger Navajojunge tanzt beim jährlichen Pow Wow (Indianerfest).

ネイティブなアメリカ文化が優美さと調和をもたらしている。

page 22

La Reservación India de Salt River (Rio Salado), con la ciudad al fondo.

Vue de la réserve de la Rivière Salée (tribu Pima), avec la ville dans le lointain.

Das Salt River Indianer Reservat, in der Ferne die Stadt.

ソルトリバーのインディアン居住区から町並みを遠くに見渡す。

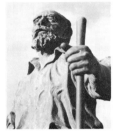

page 23

El Reverendo Winfield Scott, fundador de Scottsdale. La estatua, del artista arizonense Buck McCain, se erigió en el sitio donde se encontraba la casa de Scott.

Le révérend Winfield Scott, fondateur de Scottsdale. La statue, par l'artiste Buck McCain, est érigée à l'endroit où s'élevait la maison de Scott.

Reverend Winfield Scott, der Gründer von Scottsdale. Die Statue, von dem Künstler Buck McCain aus Arizona geschaffen, wurde zur Hundert-jahrfeier von Scottsdale genau an der Stelle von Scotts Haus errichtet.

スコッツデールの創立者であるウインフィールド・スコット神父。アリゾナ州の芸術家のバック・マックイン氏によって作られた銅像は１９８８年に１００周年を記念してスコット神父の家があった場所に立てられた。

page 24

Scottsdale esta enriquecido con los símbolos del Viejo Oeste.

Scottsdale reste riche en témoignages de l'Ouest des légendes.

Scottsdale ist reich an Sinnbildern des Alten Westens.

古き良き時代の西部を象徴するスコッツデール。

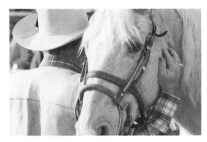

page 25

La amistad varonil entre hombre y caballo ha sido alimentada por generaciones de opresión compartida.

La complicité virile entre le cavalier et sa monture est née de siècles d'épreuves partagées.

Die männliche Vertrautheit zwischen Mann und Pferd wurde genährt durch Generationen geteilter Mühsal.

何代にもわたって苦労を分かち合って育まれた人間と馬との強き友情。

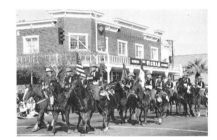

page 26

El desfile tirado por caballos más grande de mundo, la Parada del Sol ofrece cada año la oportunidad de revivir los momentos pintorescos de la historia.

La plus grande parade équestre au monde, la Parada del Sol fait chaque année revivre des épisodes d'une épopée haute en couleurs.

Die größte, nur von Pferden gezogene Parade der Welt, die Parada del Sol, bietet jedes Jahr Gelegenheit farbenfrohe Ereignisse aus der Geschichte wiederzubeleben.

世界最大の馬のパレード、パラダ・デル・ソルは様々な歴史の場面を思い出させてくれる。この派遣隊はフォート・ハチューカに駐屯する合衆国騎兵帯の第四連隊を代表している。この隊によってアパッチ族のジェロニモが１８８６年に捕まえられた。スコッツデール市設立の２年前のことである。

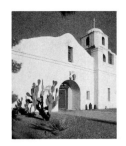

page 27

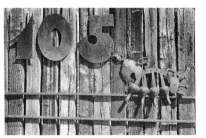

page 28

Nuestra Señora del Perpetuo Socorro, la primera iglesia Católica de Scottsdale, se construyó en 1933 por emigrantes mexicanos quienes fabricaron a mano los 14,000 ladrillos de adobe del edificio original. Hoy en día es la sede de la Orquesta Sinfónica de Scottsdale.

Our Lady of Perpetual Help, Scottsdales erste katholische Kirche, wurde im Jahr 1933 von mexikanischen Einwanderern gebaut, die die 14.000 Adobeziegel des Originalgebäudes mit der Hand fertigten. Sie ist heute der Sitz des Scottsdale Symphonieorchesters.

Notre-Dame-du-Perpétuel-Secours, la première église catholique de Scottsdale, fut construite en 1933 par des immigrants mexicains qui fabriquèrent eux-mêmes, à la main, les 14.000 blocs d'adobe qui entrèrent dans la construction du bâtiment d'origine. Elle abrite aujourd'hui l'Orchestre Symphonique de Scottsdale.

私達が永遠なる救いの神と呼ぶスコッツデールにおける最初のカトリック教会は１９３３年にメキシコ人移民の手作りによって１４００のアドビ煉瓦を使って作られた。

La casa que el ingeniero George Ellis construyera para su familia en los años 1930s fue hecha de maderas recuperadas de un canal cercano. Por la puerta de Cattle Track (senda para ganado) se exhibe la obra en hierro del escultor Ron Hadgerty.

Das Haus, das Ingenieur George Ellis, für seine Familie um 1930 erbaute, wurde errichtet aus Redwood Brettern, die aus dem nahegelegenen Kanal gefischt wurden. Neben dem Tor am Cattle Track wird eine Eisenarbeit des Bildhauers Ron Hadgerty gezeigt.

La maison que l'ingénieur George Ellis construisit pour sa famille dans les années trente était faite de planches en bois de sequoia récupérées du canal voisin, dont elles constituaient le fond. Une oeuvre du sculpteur-ferronnier Ron Hadgerty (aujourd'hui locataire d'une annexe) jouxte le portail d'accès sur Cattle Track.

１９３０年に技師であるジョージ・エリスが家族のために作った家は近くの運河から運んできたアカスギの板で出来ている。ゲートの脇にロン・ハジャテーの作による鉄樹で出来たキャトル・トラックが展示してある。

page 29

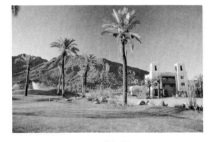

pages 30-31

El negocio más antiguo aún en servicio en Scottsdale es una cerrajeria inaugurada por George Cavalliere en 1910. Fue construida en "las afueras de la ciudad", de acuerdo con las instrucciones de los fundadores de la ciudad.

Das älteste, ununterbrochen betriebene Geschäft in Scottsdale ist die Schmiede, die von George Cavalliere im Jahr 1910 gegründet wurde. Sie wurde "außen am Rande der Stadt" gebaut, gemäß den Anweisungen der Stadtgründer.

Le plus ancien commerce de Scottsdale en fonctionnement ininterrompu est la forge et atelier de serrurerie que George Cavalliere ouvrit en 1910, et qu'il installa "hors des limites de la ville", en accord avec les recommandations des fondateurs.

スコッツデールで最も昔から続いている商売は１９１０年にジョージ・キャバリアーが始めた鍛冶やである。

La casa del artista Jessie Benton Evans se convirtió en el Jokake Inn en 1927, el segundo centro recreacional de Scottsdale. Pronto atrajo a celebridades de todas partes de los Estados Unidos. Las torres son ahora una marca distintiva en los patios del centro recreacional The Phoenician.

Das Haus des Künstlers Jessie Benton Evans wurde im Jahre 1927 die Jokake Inn, Scottsdales zweites innerstädtisches Ferienhotel. Sehr bald zog es viele Berühmtheiten aus den ganzen Vereinigten Staaten an. Die Türme sind heute ein charakteristisches Kennzeichen auf dem Gelände des Phoenician Hotels.

La résidence de l'artiste Jessie Benton Evans devint Jokake Inn en 1927. Trés vite on y vit des célébrités en provenance de tous les Etats-Unis. Les tours qui en ont été conservées se trouvent à présent sur la propriété du palace Le Phoenicien.

芸術家ジェシー・ベント・エバンスの家は１９２７年にジョカケ・インとなった。これはスコッツデールで２番目のリゾートである。やがて全米から多くの著名人を集めるに至った。このタワーは今では傑出したランドマークとも言えるべきフェニッシアン・リゾートの敷地となっている。

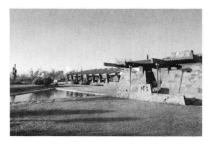

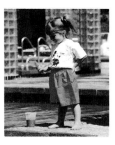

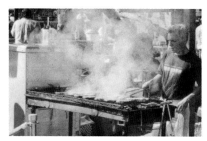
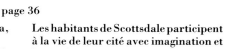

page 33

Despues de los modestos inicios a finales de los años 1930's, la casa invernal, oficina y escuela del arquitecto Frank Lloyd Wright fue el primer sitio en Scottsdale en ser enlistado en el Registro Nacional de Lugares Historicos.

Après de modestes débuts à la fin des années 30, la résidence d'hiver de Frank Lloyd Wright, également cabinet d'architecture et centre de formation, fut première dans Scottsdale à figurer à l'Inventaire National des Sites Historiques.

Nach bescheidenen Anfängen in den späten Dreißigern, wurde das Winterhaus, das Büro und die Schule des Architekten Frank Lloyd Wright als erstes in das Nationalverzeichnis über historische Stätten eingetragen.

１９３０年代後半のゆっくりした成長の後建築家フランク・ロイド・ライトの冬期の家、オフィス、学校等がスコッツデールで最初の歴史的意義のある建物して認識された。１９８２年にはアメリカ合衆国のランドマークとして登録されている。

page 35

Una joven imagina sus logros futuros en la playa de arena del centro recreacional Hyatt Regency.

Une petite fille rêve de projets grandioses à la surprenante plage de sable de l'hotel Hyatt Regency.

Eine junge Dame träumt von ihren zukünftigen Großtaten am Sandstrand des Hyatt Regency Hotels.

少女が未来を夢見る。ハイアット・リージェンシーリゾートの砂浜にて。

page 36

La gente de Scottsdale es dedicada, creativa, y animosa:
 – Un miembro del Concilio Cultural de Scottsdale, se hace cargo de la barbacoa en el Festival de las Artes.
 – Young Heather orgullosamente porta los colores del equipo de la Liga Nacional de Futbol (NFL), los Cardenales de Phoenix.
 – El alcalde Drinkwater con el chef Gutierrez en el Festival Culinario.
 – Los pasajeros del carruaje Wells Fargo disfrutan de un paseo durante La Parada del Sol.

Die Menschen in Scottsdale sind veantwortungsbewußt und kreativ:
 – Ein Mitglied des Kulturausschusses arbeitet am Grill während des Kunstfestivals.
 – Die junge Heather trägt stolz die Farben der Cardinals, des Football Teams von Phoenix.
 – Bürgermeister Drinkwater mit Küchenchef Gutierrez beim Feinschmeckerfestival.
 – Passagiere der Wells Fargo Postkutsche genießen die Fahrt während der Parada del Sol.

Les habitants de Scottsdale participent à la vie de leur cité avec imagination et bonne humeur:
 – Un membre du Conseil Culturel tient un barbecue au Festival des Arts.
 – La jeune Heather arbore fièrement les couleurs de l'équipe de football de Phoenix.
 – Le maire Drinkwater concocte un menu gastronomique avec le Chef Gutierez au Festival Culinaire.
 – Les passagers de la diligence de Wells Fargo saluent la foule de la Parada del Sol.

スコッツデールの市民は熱心で、創造的で遊び上手である。

左上から時計回りの方向：

−スコッツデール文化評議会のスタッフが芸術祭でバーベキューをしている。

−若い女性がフットボール・リーグのチームであるフェニックス・カーディナルスの旗をゆうゆうと翻している。

−ドリンクウォータ市長が料理のフェスティバルでギティエレス・シェフと料理法を披露している。

−ウエルズファーゴの駅馬車の乗客がパラダ・デル・ソルの祭りをエンジョイしている。

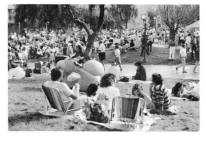

page 37

De octubre a mayo, los patios del Centro Civico dan la bienvenida a una variedad de eventos bien concurridos.

D'octobre à mai, les jardins du Centre Civique sont le théatre d'une quantité de manifestations à succès.

Von Oktober bis Mai beherbergt die Scottsdale Mall eine Vielzahl von gutbesuchten Ereignissen.

１０月から５月まで、ここスコッツデールモールでは様々なイベントが催され、多くの人々で賑わう。

page 38

En sentido de las manecillas del reloj, de izquierda arriba:
 – Un potro arabe es dirigido con orgullo a una presentación de premios.
 – Durante la temporada de rodeo, unos jóvenes jinetes compiten en las carreras de barriles.
 – Unos jóvenes bailarines reviven una sabrosa tradición del Oeste.
 – El tema de la villa de Rawhide - o Qué divertido era el Oeste!

Depuis le haut à gauche:
 – Un poulain arabe est fièrement escorté jusqu'à l'arène où seront décernés les prix.
 – Pendant la saison des rodéos, de jeunes cavaliers s'affrontent dans la Course aux Tonneaux.
 – De joviales danseuses font revivre une des traditions de l'Ouest.
 – Rawhide, ou Comment l'Ouest Fait Votre Conquête!

Im Uhrzeigersinn von oben links:
 – Ein junger Araber wird stolz zu einer Preisverteilung geführt.
 – Während eines Rodeos wetteifern junge Reiter in einem Faßrennen.
 – Vergnügte Tänzer lassen eine pikante Western Tradition aufleben.
 – Das Dorf Rawhide - oder wie amüsant der Westen war!

左上から時計回りの方向：

−若いアラビア馬が表彰代に勇ましく導かれている。

−ロデオの期間中、若いカーボーイ達は「たるレース」を競い合う。

−底抜けに明るいダンサー達がスパイスのきいた西部の伝統を思い出させる。

−古き良き時代の西部を思わせる観光スポット、ローハイド。

page 39

La resplendor del sol de Arizona permite las actividades al aire libre durante todo el año. Aquí, un grupo visitante se agazaja con una parrillada gigante.

Le ciel toujours bleu de l'Arizona autorise les activités de plein air toute l'année. Ici un groupe de visiteurs participe à un barbecue géant.

Arizonas Sonnenschein macht es möglich das ganze Jahr über Aktivitäten im Freien nachzugehen. Hier wird eine Besuchergruppe mit einem riesigen Grillfest bewirtet.

すばらしいアリゾナの気候のため１年を通じて屋外でも活動が楽しめる。ビッグなバーベキューでもてなされる旅行者。

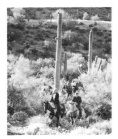

page 40

A solo minutos de la oficina, estos paseantes a caballo toman un descanso, alejados de la vida urbana.

A quelques minutes seulement de leurs bureaux, ces cavaliers passent de la vie urbaine à la solitude du désert.

Minuten vom Büro, genießen Geländereiter eine Unterbrechung vom Stadtleben.

オフィスを離れ、また都会生活をはなれてしばし休憩を取る。

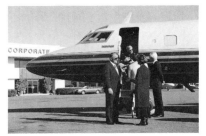

page 41

Unos ejecutivos atareados empiezan su día en el Aeropuerto Municipal de Scottsdale.

Quelques représentants du monde des affaires entament une journée chargée à l'aéroport municipal de Scottsdale.

Geschäftige Manager beginnen ihren Tag am Scottsdale Municipal Airport.

多忙な会社のエグゼクティブがスコッツデール市営空港でその日の仕事を始める。

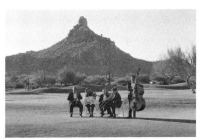

page 42

En una vista Fellinesca en el campo del golf Troon, con el Pico Pinnacle como magno telón de fondo, unos músicos de la Sinfónica de Phoenix ensayan felizmente una pieza un tanto improvida, antes de una presentación al aire libre.

Dans une ambiance à la Fellini, sur le golf de Troon, avec Pinnacle Peak en grandiose arrière-plan, quelques musiciens de l'Orchestre Symphonique de Phoenix répètent dans la bonne humeur un improbable morceau, avant de participer à un concert en plein air.

In einer Felliniartigen Kulisse auf dem Troon Golf Course, mit Pinnacle Peak als majestätischem Hintergrund, probt das Scottsdale Symphonieorchester fröhlich ein etwas zweifelhaftes Stück vor einer Freiluftaufführung.

雄大なピナクル・ピークを背景にフェリニケを設定したトゥルーン・ゴルフ場ではフェニックス交響楽団のメンバーが屋外コンサートに向け楽しく練習している。

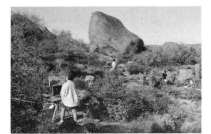

page 43

Los artistas encuentran en el escenario del desierto el objeto de su inspiración, como estos dedicados pintores de la Escuela de Artistas de Scottsdale.

Les artistes, comme ici quelques membres de l'Ecole d'Art de Scottsdale, trouvent dans le désert une inépuisable source d'inspiration.

Künstler finden die Wüstenlandschaft ein inspirierendes Thema, wie diese hingebungsvollen Maler von der Scottsdale Künstler Schule.

スコッツデール芸術学院の生徒達が砂漠の風景にインスピレーションを見いだす。

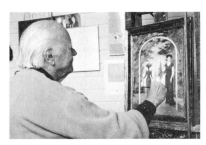

page 44

Philip C. Curtis fue uno de los primeros artistas en establecerse en Scottsdale en los años 1930's. Su sensible arte surrealista le ha ganado reconocimiento internacional.

Philip C. Curtis fut parmi les premiers artistes à s'établir à Scottsdale, dans les années 30. Son surréalisme raffiné lui a gagné un renom international.

Philip C. Curtis war einer der ersten Künstler, die sich in Scottsdale um 1930 niedergelassen haben. Seine empfindsame surrealistische Art hat ihm weltweite Anerkennung gebracht.

フィリップ・カーティス氏は1930年にスコッツデール移り住んだ最初のアーティストである。彼の繊細で、超現実的な芸術は世界的に認識を得ている。

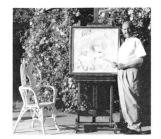

page 45

Earl Linderman crea de su imaginación un mundo lleno de color y sensaciones, habitado por el humor y la nostalgia.

De son imagination débordante, Earl Linderman a tiré un univers coloré et sensuel, tout d'humour et de nostalgie.

Earl Linderman gestaltet aus seiner Phantasie eine farben- und sinnenfrohe Welt, belebt von Humor und Sehnsucht.

アール・リンダーマン氏はカラフルで感覚的な世界をイマジネーションから産み出しており、これにはユーモアとノスタルジーが内在している。

page 46

El mundialmente conocido artista Fritz Scholder explora el universo Shakesperiano de las figuras humanas atormentadas por los poderes del color.

Fritz Scholder est aujourd'hui mondialement connu. Son oeuvre recrée un monde shakespearien de personnages étranges, possédés par les pouvoirs de la couleur.

Der weltbekannte Künstler Fritz Scholder erkundet ein Shakespearianisches Universum von menschlichen Figuren, gepeinigt von der Kraft der Farben.

世界的に著名な芸術家であるフリッツ・ショルダー氏は色彩の威力によって苦しめられたシェクスピアの世界における人間像を捜し求めている。

page 47

La escultora francesa Annja se unió recientemente a la comunidad cosmopolita de artistas quienes elijieron Scottsdale como su sitio de inspiración. Ella divide su tiempo entre sus estudios en Scottsdale y la Riviera Francesa.

Die französische Bildhauerin Annja trat vor kurzem der kosmopolitischen Gemeinschaft bei, die Scottsdale als ihren Ort der Inspiration gewählt hat. Sie teilt ihre Zeit zwischen ihrem Atelier in Scottsdale und dem an der französischen Riviera.

Le sculpteur français Annja a récemment rejoint la communauté internationale d'artistes qui ont adopté Scottsdale comme lieu d'inspiration et de travail. Elle partage son temps entre ses studios de Scottsdale et de Mougins, sur la riviera française.

フランス人の彫刻化のアンジャさんはコスモポリタン芸術家コミュニティーに入会した。彼女はスコッツデールを芸術のためのインスピレーションの場所であると考えている。フレンチ・リビエラと同様にスコッツデールのスラジオとで時間を過ごしている。

page 48

Muchos de los más grandes jugadores se sienten atraídos cada año por los torneos de golf en Scottsdale. El Phoenix Open representado aquí atrae su buena parte de aficionados al golf.

Beaucoup parmi les plus grands joueurs de notre époque viennent participer chaque année aux championnats de golf de Scottsdale. Le Phoenix Open que l'on voit ici attire nombre de passionnés.

Viele Spitzengolfspieler werden jedes Jahr von Scottsdales Golfturnieren angezogen. Das hier gezeigte Phoenix Open zieht seinen Teil von Golfliebhabern an.

多くのトップゴルフプレーヤーがスコッデールのゴルフトーナメントに魅力を感じている。フェニックス・オープンはゴルフの熱狂家達から多くの支持を得ている。

page 49

Padre e hijo se presentan con los populares moradores del Parque Chaparral.

Un père et son fils font des civilités aux trés populaires résidents de Chaparral Park.

Vater und Sohn machen sich mit den beliebten Bewohnern des Chaparral Parks bekannt.

シャバレル公園で過ごす父と子。

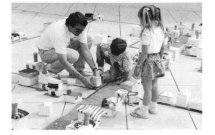

page 50

El diseñar una ciudad hermosa es asunto que les concierne a todos. A estos pequeños se les ha introducido a manera de juego, a la planeación de la ciudad en el Festival Anual de las Artes.

Réaliser la plus belle ville possible est l'affaire de tous. Les jeunes sont initiés à l'urbanisme pendant le Festival Annuel des Arts.

Eine schöne Stadt zu schaffen ist jedermanns Aufgabe. Beim jährlichen Kunstfestival werden junge Menschen spielerisch in die Stadtplanung eingeführt.

美しい町作りは皆の願いです。芸術祭で都市計画の説明を楽しく受ける子供達。

pages 52-53

Atravez de los años, Scottsdale se ha expandido hacia el norte, hacia las faldas de las Montañas McDowell. A distancia se aprecia el contorno elevado de Four Peaks.

Au cours des années, Scottsdale s'est étendue vers le nord, jusqu' aux pentes des monts McDowell, que domine la silhouette massive des Quatre-Pics.

In den letzten Jahren hat sich Scottsdale nach Norden bis zu den Ausläufern der McDowell Berge ausgedehnt. In der Ferne die überragende Silhouette von Four Peaks.

スコッツデール市は町の北、マクドゥウェル山脈の麓まで拡張しています。遠くにそびえたつのはフォーピーク連邦の山並です。

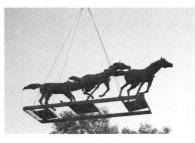

page 54

"Yearlings" (Añales) de la artista arizonense George-Ann Tognoni, instalado y dedicado en 1987 despues de una exitosa colecta comunitaria, adorna la entrada del centro civico.

"Jährlinge" des Arizona Künstlers George-Ann Tognoni, errichtet und gewidmet im Jahr 1987 nach einer erfolgreichen Gemeinde-Sammelaktion, zieren den Eingang der Scottsdale Mall.

"Les Poulains", un bronze de l'artiste arizonienne George-Ann Tognoni, fut mis en place et inauguré en 1987, grâce à une collecte publique et aux donations des habitants. La statue ouvre l'accès du Scottsdale Mall, le centre civique de Scottsdale.

アリゾナの芸術家ジョージアン・トグノーリの作による「イアリング」は地域の募金の成功を記念して１９８７年に立てられた。スコッツデールモールの玄関を優雅に引き立てている。

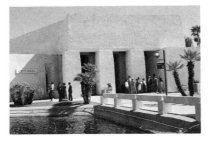

page 55

Unos oficiales de la ciudad frente al Ayuntamiento. El complejo "Centro Civico", el cual tambien incluye una biblioteca y un centro de artes, fue diseñado por el arquitecto Bennie Gonzales y completado a mediados de los años 1970's.

Offizielle der Stadt diskutieren vor dem Rathaus. Der Gebäudekomplex des Civic Center, der auch eine Bücherei und ein Kunstzentrum beherbergt, wurde von dem Architekten Bennie Gonzales geplant und Mitte der Siebziger vollendet.

Quelques édiles se sont joints à une discussion animée devant l'Hotel de Ville. L'ensemble du Centre Civique, conçu par l'architecte Bennie Gonzales et inauguré dans les années 70, comprend également une bibliothèque et un Centre des Arts.

市の役員が市役所の前で討論をしている。シビック・センターは建築家ベニー・ゴンザレス氏によるもので、１９７０年代半ばに完成を見ている。ここには図書館とアートセンターがある。

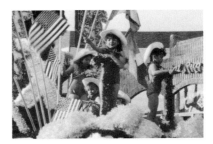

page 56

La participación comunitaria empieza desde la infancia y nunca cesa. En le sentido de las manecillas del reloj:
– Un grupo de niñas graciosamente se encargan de un carro alegorico en la Parada del Sol.
– Una nina pequeña participa en la creación de una "barda ecológica" con listones de colores.
– Los propietarios comparten el orgullo de coleccionar autos antiguos.
– Una pequeña ensaya el desfile - un negocio serio!

Mitwirkung der Gemeindemitglieder beginnt früh und hört nicht auf. Im Uhrzeigersinn von oben links:
– Kinder besetzen mit Charme einen Festwagen der Parada del Sol.
– Ein junges Mädchen beteiligt sich an der Gestaltung eines "ökologischen Zauns" mit farbenfrohen Bändern .
– Besitzer teilen den Stolz an "Oldtimern"
– Ein kleines Mädchen probt für die Parade - ein ernsthafte Sache!

La participation à la vie de la cité commence tôt. De haut en bas, dans le sens des aiguilles d'une montre:
– Des fillettes animent avec grâce un char de la Parada del Sol.
– Une petite fille apporte sa contribution à une "clôture écologique".
– Les collectionneurs font défiler avec fierté leurs superbes tacots.
– Une fillette s'aligne pour la parade – avec quel sérieux!

早いスタートを切り、止むことを知らない。左上より時計回り：
ーパラダ・デル・ソルフロート上で朗らかな子供のスタッフ。

ー少女がカラフルなリボンでデザインを作り、参加している。

ークラシックカーのオーナーが自慢の車を見せる。

ー少女が真剣にパレードの練習に励む。

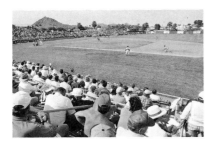

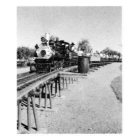

page 57

Partidos de entrenamiento de la liga de beisbol Cactus en el viejo estadio de Scottsdale, antes de que se construya uno nuevo para la temporada de 1992.

L'entraînement des équipes de base-ball membres de la Ligue des Cactus s'effectue dans le vieux stade de Scottsdale, lequel sera reconstruit pour la saison de 1992.

Die Baseballtrainingsspiele der Cactus Liga sind eine Gelegenheit für die San Francisco Giants und die Cleveland Indians im alten Stadion von Scottsdale aufeinanderzutreffen.

野球のトレーニング用の試合として行なわれるカクタス・リーグはサンフランシスコジャイアンツとクリーブランド・インディアンスがここオールド・スコッツデールのスタジアムでゲームを行なう。市民が野球を満喫するチャンスである。新しいスタジアムは１９９２年にオープンの予定。

page 58

El "Paradise & Pacific" lleva a más de 160,000 visitantes alrededor del Parque Ferroviario McCormick cada año.

Chaque année, le train "Paradise & Pacific" transporte plus de 160,000 visiteurs autour du Parc Ferroviaire McCormick.

Die Paradise & Pacific Eisenbahn fährt mehr als 160.000 Besucher jedes Jahr durch den beliebten McCormick Railway Park.

パラダイス・アンド・パシフィック社はマコーミック鉄道公園で毎年１６万人以上の観光客を汽車に乗せている。

page 59

En el sentido de las manecillas del reloj de izquierda arriba:
– La locomotora Baldwin, en exhibición en el Parque Ferroviario McCormick, fue construída en 1907.
– Guy Stillman, iniciador y disenador del parque, sobre la plataforma del carro Roald Amundsen.
– Unos niños muestran interés en otro tipo de transporte en la tradición pura del Oeste.

Im Uhrzeigersinn von oben links:
– Die Baldwin Lokomotive, die im McCormick Park ausgestellt wird, wurde im Jahr 1907 gebaut.
– Guy Stillman, Initiator und Planer des Parks, zeigt Nostalgie für die großen Eisenbahnen der Vergangenheit, hier auf der Plattform von Roald Amundsens Waggon.
– Kinder zeigen Interesse an anderen Verkehrsmitteln in reiner Western Tradition.

Du haut à gauche, dans le sens des aiguilles d'une montre:
– La locomotive Baldwin, construite en 1907, fut retirée du trafic en 1961.
– Guy Stillman, fondateur du Parc, Montre quelque nostalgie sur la plateforme du pullman présidentiel Roald Amundsen.
– Des enfants montrent de l'intérêt pour un autre moyen de transport typique de l'Ouest.

左上から時計回り：

マコーミック鉄道公園で展示されているボールドウィン機関車は１９０７年に完成。アメリカ南西部で鉱業用に使用される。この公園の創立者でありデザイナーでもあるガイ・スティルマン氏は過去の偉大な鉄道をロールド・アムンゼン車両のプラットフォームにおいてノスタルジーを演出している。これはアメリカ合衆国大統領、又は貴賓客のために個人的に作られたものである。

ー子供達が西部の伝統的な輸送の方法として機関車に興味を示している。

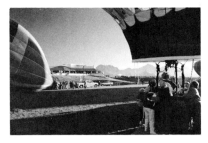
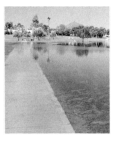
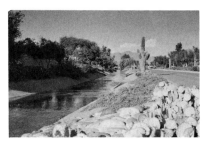
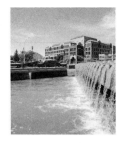

pages 60-61

La carrera de globos de la Sociedad Americana del Cancer se inaugura en medio del cielo siempre azul de Arizona desde el campo de polo de Westworld.

Une course de ballons organisée par la Société de Lutte contre le Cancer prend le départ depuis le terrain de polo de WestWorld.

Das Heißluftballonrennen der amerikanischen Cancer Society hebt ab in den immerwährend blauen Himmel Arizonas vom Westfield Polofeld.

ウェストワールドのポロ競技場ではアメリカ癌協会による気球レースが透き通るようなアリゾナの青空の下で開催されている。

page 63

El Aluvión Indio (Indian Bend Wash) cumple fielmente su propósito, obligando a los golfistas aquí a ajustar su estrategia.

Le parc inondable d'Indian Bend remplit parfaitement son rôle, obligeant parfois les golfeurs à ajuster leur jeu.

Der Indian Bend Wash dient gewissenhaft seinem Zweck und zwingt Golfer dadurch ihre Strategie umzustellen.

インディアンベンドウッシュと呼ばれる水路に水が流れる。水路を避けるためにゴルファーが作戦を練っている。

page 64

Los jardines callejeros sobre Vía Linda ilustran la preocupacion de la comunidad por el ambiente.

La qualité du paysage urbain de Via Linda illustre un omniprésent souci de respect et d'intégration de la nature.

Gärtnerische Gestaltung an der Via Linda veranschaulicht das Umweltbewußtsein der Gemeinde.

ビアリンダ通りの美しい町並みの作りが地域の環境に対する関心を反映している。

page 65

El Canal Arizona en la intersección de las vias Camelback y Scottsdale.

Vue du Canal Arizona à l'intersection de Camelback et de Scottsdale Roads.

Der Arizona Kanal an der Kreuzung von Camelback und Scottsdale Road.

アリゾナ運河がキャメルバック通りとスコッツデール通りの交差点を横切っている。

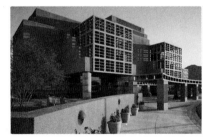
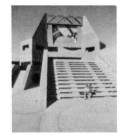

pages 66-67

La adicion de una Clínica Mayo la cual se expande rápidamenta, trae consigo una nueva dimensión a la ya talentosa comunidad sanitaria de Scottsdale.

L'addition d'une clinique Mayo – en expansion rapide – apporte une dimension nouvelle à une communauté médicale déja riche en talents.

Der Anbau der schnell wachsenden Mayo Klinik, bringt der schon an Talenten reichen Gesundheitsfürsorge von Scottsdale eine neue Größe.

ここスコッツデールでは既に著名な健康対策の地域として有名であるが、ここマヨクリニックでも早いテンポで拡張工事が進み新しい局面を作り出している。

page 68

Scottsdale se beneficia de la gran cercanía a la Universidad Estatal de Arizona, una de las más grandes en los Estados Unidos. Un ambicioso programa de desarrollo trae un flujo de nuevas instalaciones con lo más moderno en diseno.

Scottsdale profitiert von der direkten Nachbarschaft der Arizona State Universität, einer der größten in den Vereinigten Staaten. Ein ehrgeiziges Entwicklungsprogramm bringt einen Strom von Einrichtungen, die auf dem neuesten Stand der Erkenntnis sind.

Scottsdale bénéficie de la proximité de l'Université de l'Etat d'Arizona, l'une des plus importantes des Etats-Unis. Un ambitieux programme de développement a conduit à la réalisation récente de toute une série d'équipements et de constructions à la pointe de la technologie et du style.

スコッツデールは全米でも有数の規模を誇るアリゾナ州立大学と隣接している。積極的な開発プログラムによって最新鋭の施設が作られている。

page 69

Algunos estudiantes de ASU apoyan con todo el corazón a su equipo de fútbol.

Les étudiants d'ASU apportent un soutien sonore et coloré à leur équipe de football.

ASU Studenten unterstützen ihr Football Team mit ganzem Herzen.

アリゾナ州立大学の学生が母校のフットボールのチームを全力で応援している。

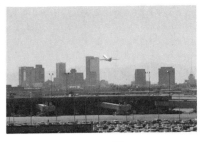

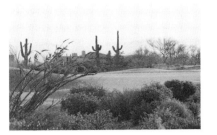

page 70

Sky Harbor, uno de los aeropuertos con mayor crecimiento en los Estados Unidos, conecta al Valle del Sol con el pais entero y aun mas alla.

Sky Harbor International, l'un des aéroports les plus actifs des Etats-Unis, rattache la Vallée du Soleil à l'ensemble du pays et au-delà.

Sky Harbor, einer der am schnellsten wachsenden Flughäfen der Vereinigten Staaten, verbindet das "Valley of the Sun" (Tal der Sonne) mit dem ganzen Land und darüber hinaus.

全米で最も成長の早いスカイハーバー国際空港は、ここバレー・オブ・ザ・サン（フェニックス地域のニックネーム）を全米、全世界につなげている。

page 71

La silueta aérea del adyacente Phoenix sugiero a los residentes de Scottsdale un mundo distante.

Phoenix, toute proche, suggère un monde lointain aux résidents de Scottsdale.

Die Silhouette vom benachbarten Phoenix zeigt den Einwohnern von Scottsdale eine in der Ferne liegende Welt.

隣接する都市フェニックスのスカイラインはスコッツデールの住民にとっては遠い町並みである。

pages 72-73

El estilo de vida de Scottsdale.

Scottsdale représente une manière de vivre, un style.

Lebensstil in Scottsdale.

スコッツデールのライフスタイル。

pages 74-75

Los lagos añaden frescura y disfrute visual a muchos desarrollos residenciales.

Des lacs apportent fraîcheur et séduisantes perspectives à de nombreux ensembles résidentiels.

Seen bringen zusätzliche Kühle und Genuß fürs Auge in viele Wohngebiete.

湖は多くの住宅開発にとって視覚的な涼しさを与える。

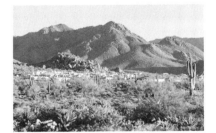

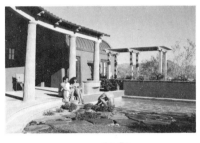

page 76

Troon esta encajada en la cordillera al norte de Scottsdale.

Le village de Troon se niche dans les montagnes du nord de Scottsdale

Troon Village ist in die Bergkette von Nord-Scottsdale eingebettet.

トゥルーン・ビレッジは北スコッツデールの山並にある。

page 77

Los impresionantemente hermosos sitios residenciales exigen un diseño inovativo. Este fue inspirado en las técnicas milenarias de albañileria de los Anasazi, unos de los primeros pobladoras de Arizona.

Überwältigend schöne Bauplätze verlangen kreatives Design. Dieses wurde inspiriert von den tausend Jahre alten Bautechniken der Anasazi, Arizonas frühen Einwohnern.

Des sites résidentiels d'une beauté à couper le souffle invitent à des architectures inventives. Celle-ci a été inspirée par la maçonnerie millénaire des Anasazi, les plus anciens habitants connus de l'Arizona.

ユニークな家が素晴らしい敷地に調和している。特にこの家はアリゾナの先住民であるアナサジ・インディアンが何千年もの間使用してきた技術を利用している。

pages 78-79

Las piscinas son una extensión de la sala de estar la mayor parte del año.

Les piscines sont une extension de la salle de séjour la majeure partie de l'année.

Den größten Teil des Jahres sind Schwimmbäder eine Erweiterung der Wohnzimmer.

一年間を通じてプールはリビングルームの延長と言えよう。

 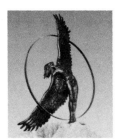 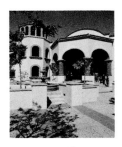

pages 80-81

Los centros empresariales ofrecen un ambiente de recreo.

Les centres d'affaires de Scottsdale ressemblent à des hotels de luxe.

Business-Zentren bieten eine Umgebung wie im Ferienhotel.

すばらしい環境のリゾート・オフィス。

page 82

La creatividad y diversidad caracterizan la fachada del mundo ejecutivo de Scottsdale.

Créativité et variété caractérisent la partie la plus apparente du monde des affaires à Scottsdale.

Kreativität und Vielfältigkeit charakterisieren die Einstellung von Scottsdales Geschäftswelt.

創造する力と多様性がスコッツデールのビジネスの世界においての特徴である。

page 83

La nueva matriz de Giant Industries refleja la filosofía ejecutiva convivial de Scottsdale.

Le nouveau siège de Giant Industries illustre le caractère convivial que prennent les relations professionnelles à Scottsdale.

Die neue Zentrale von Giant Industries spiegelt Scottsdales lebensfrohe Einstellung zu Gesellschaften.

ジャイアント・インダストリー社の本社がスコッツデールの明るく楽しいコーポレート・フィロソフィーをつくりだしている。

 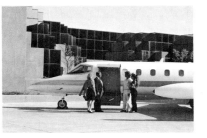 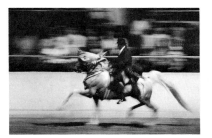 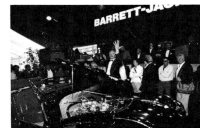

page 84

Una variedad de algunos de los más populares rótulos comerciales de Scottsdale.

Quelques-unes des enseignes les plus connues de Scottsdale.

Eine Auswahl von Scottsdales populären Reklameschildern.

スコッツデールにおいては色とりどりの看板が見られる。

page 85

El aeroparque de Scottsdale ofrece la conveniencia única de tener un aeroplano a unos cuantos pasos de la oficina.

L'aéroport de Scottsdale offre à un homme d'affaires cet avantage unique de pouvoir garer son avion dans le parking de ses bureaux.

Der Scottsdale Airport bietet die einzigartige Bequemlichkeit ein Flugzeug innerhalb einiger Gehminuten vom Büro zu halten.

スコッツデール・エアーパークと呼ばれるオフィスビル郡では飛行場まで徒歩で行かれる便利さである。

page 86

Un caballo árabe desfila con gracia en la Muestra Arabe.

Un cheval arabe parade avec grande allure au cours du All-Arabian Horse Show.

Ein Araber stellt sich anmutig zur Schau bei der jährlichen Araberschau.

例年のオールアラビアショーで優雅にアラビア馬が走っている。

page 87

La venta de subasta Barret-Jackson, la más grande del mundo en carros de colección, se celebra cada año en WestWorld.

La vente Barrett-Jackson, la plus importante au monde pour les voitures de collections, tient ses enchères à WestWorld.

Die Barrett-Jackson Auktion, die größte in der Welt für Oldtimer, wird jedes Jahr in WestWorld abgehalten.

ここウエスト・ワールドにおいては世界最大の恒例のクラシックカーのオークションであるバレット－ジャクソン・オークションが開催される。

page 88

El ir de compras en el Viejo Scottsdale es una experiencia visual.

Le lèche-vitrines dans le Vieux Scottsdale réserve aux visiteurs nombre de surprises.

Einkaufen im alten Scottsdale ist ein Erlebnis für die Augen.

オールド・スコッツデールでするショッピングは目の保養になる。

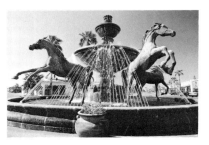

page 89

Los caballos de bronce que emergen de esta fuente de la Avenida Quinta fueron donados a la ciudad por el artista Bob Parks.

Les chevaux de bronze qui semblent surgir de la fontaine de Fifth Avenue ont été offerts à la ville par l'artiste Bob Parks.

Die Bronzepferde die aus dem Brunnen der Fifth Avenue auftauchen, wurden der Stadt von dem Künstler Bob Parks gestiftet.

五番街の噴水にあるブロンズ像の馬は芸術家ボブ・パークスによって市に寄付された。

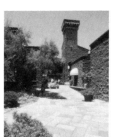

page 90

Visitar las tiendas en Scottsdale no es nada convencional.

Le shopping à Scottsdale n'a rien de conventionnel.

Einkaufen in Scottsdale ist nichts Konventionelles.

型にはまらないスコッツデールでのショッピング。

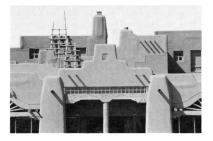

page 91

Papago Plaza es una colorida resemblanza del antiguo estilo territorial.

Papago Plaza est une évocation colorée du vieux style "territorial" (lorsque l'Arizona n'était encore qu'un territoire et non un Etat).

Papago Plaza ist eine farbenfrohe Erinnerung an den alten Territorialstil.

パパゴプラザはカラフルな古いスタイルを懐古させる。

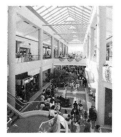

page 92

La Plaza Scottsdale Fashion se ha expandido para convertirse en el centro comercial más grande del Valle.

Scottsdale Fashion Square s'est agrandi au point de devenir l'un des plus grands centres commerciaux de la Vallée.

Der Scottsdale Fashion Square wurde zu einer der größten Shopping Malls des Tales erweitert.

スコッツデール・ファッション・スクエアーはこの地域で最大の規模のショッピングモールに拡張されつつある。

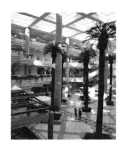

page 93

Con el tamaño de una catedral, la Galleria Scottsdale hace de el ir de compras un verdadero paraiso.

De la taille d'une cathédrale, la Scottsdale Galleria est un paradis pour les amateurs de lèche-vitrines.

Die Scottsdale Galleria ist ein Einkaufshimmel, wie eine Kathedrale gebaut.

スコッツデール・ギャラリアは大聖堂ほどの規模がありショッピングの天国である。

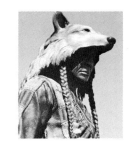

page 94

"Lluvia en la Cara", una estatua en bronce de tamaño natural del artista Dave McGary, es un magnífico ejemplo del arte del oeste, el cual atrae a coleccionistas de todo el mundo.

"Pluie sur le Visage", un bronze polychrome grandeur nature de l'artiste Dave McGary, illustre avec force cet art de l'Ouest qui intéresse aujourd'hui les collectionneurs du monde entier.

"Rain in the Face" (Regen im Gesicht), eine lebensgroße Statue von Dave McGary, ist ein verblüffendes Beispiel der Western Kunst, welche Sammler aus allen Teilen der Welt anzieht.

デイブ・マックゲリーによって作られた実物大のブロンズ像は世界中からコレクター達を魅了するウエスターン・アートの一例である。

page 95

El Paseo de Arte, los jueves por la noche es el destino favorito de los residentes del Valle y visitantes de invierno.

La Promenade des Arts rassemble chaque jeudi soir des amateurs de toute la Vallée ainsi que les résidents hivernaux de Scottsdale.

Der Donnerstagabend Kunstspaziergang ist ein bevorzugtes Ziel für Einwohner und Winterbesucher.

サーズデー・ナイト・ウオーク、すなわち「木曜日の夜の芸術散歩」とは、この地域の人々、又避寒をするために訪れた人々の好んでやるイベントである。

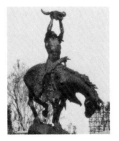

page 96

El arte es sin lugar a dudas parte del escenario callejero de Scottsdale.

Les arts sont partout présents dans les rues de Scottsdale.

Die Künste sind unverkennbar ein Teil von Scottsdales Straßenbild.

芸術はまぎれもなくスコッツデールの町並みの一場面であるといえよう。

page 97

Cristalería en exhibición en el Festival de Arte en Scottsdale.

Verrerie d'art présentée au Festival Annuel des Arts.

Glaswaren, ausgestellt beim jährlichen Kunstfestival in Scottsdale.

例年開催れるスコッツデール・アート・フェステバルにおいて展示されたガラスのおきもの。

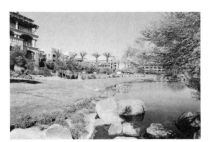

page 98

Los centros de recreo de Scottsdale compiten en elegancia y lujos. Aquí, el centro de recreo Scottsdale Princess.

Les palaces de Scottsdale rivalisent de luxe et d'élégance. Ici, les jardins de l'hotel Princess.

Die Ferienhotels in Scottsdale rivalisieren in Eleganz und Luxus. Hier, das Scottsdale Princess.

エレガンスと優雅さをかもしだすスコッツデール・プリンセス・リゾート。

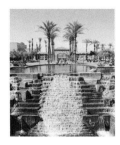

page 99

La espectacular cascada del Scottsdale Princess.

Une spectaculaire cascade anime la cour d'entrée de l'hotel Princess.

Der eindrucksvolle Wasserfall am Scottsdale Princess.

スコッツデール・プリンセスの豪華な滝。

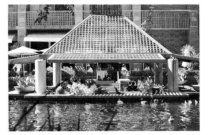

pages 100-101

El Hyatt Regency de Scottsdale: la playa de arena y el restaurante Cisne Dorado.

L'hotel Hyatt Regency de Scottsdale offre une étonnante piscine avec plage de sable. On peut aussi y apprécier le restaurant Le Cygne d'Or.

Das Hyatt Regency in Scottsdale: Der Sandstrand und das "Golden Swan" Restaurant.

ハイアット・リージェンシー・スコッツデールの砂浜とゴールデンスワン・レストラン。

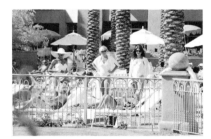

page 102

Modelaje informal en la piscina del Scottsdale Princess.

Présentation de mode décontractée à la piscine du Scottsdale Princess.

Eine zwanglose Modenschau am Pool des Scottsdale Princess.

スコッツデール・プリンセスのプール際でのインフォーマルなモデル。

page 103

La montaña Camelback se vislumbra sobre el centro de recreo Phoenician.

La montagne de Camelback domine de toute sa masse l'hotel Le Phoenicien.

Der Camelback überragt das Phoenician Hotel.

フェニッシャン・リゾートの裏にそびえ立つキャメルバック・マウンテン。

page 104

Con docenas de campos de golf para escoger, altamente reconocidos, Scottsdale se ha convertido en años recientes en una de las capitales mundiales del golf. Aquí, McCormick Ranch, con la montaña Camelback al fondo.

Mit Dutzenden von hochrangigen Golfplätzen zur Auswahl, ist Scottsdale in den letzten Jahren zu einer der Hauptstädte der Welt in Sachen Golf geworden. Hier, McCormick Ranch mit dem Camelback im Hintergrund.

Avec plus d'une douzaine de parcours de classe internationale, Scottsdale est devenue l'une des capitales mondiales du golf. On voit ici le parcours de McCormick Ranch, avec la montagne de Camelback en arrière-plan.

20数箇所のトップランキングのゴルフ場を含め、スコッツデールは世界でも名だたるゴルフのメッカとなっている。ここはマコーミック・レンチ・ゴルフ場、キャメルバック・マウンテンを背景にしている。

page 105

La Casa Club en el Desert Highlands ofrece vistas sorprendentes. Fue calificada en 1990 como la tercera más hermosa en existencia.

Le club-house de Desert Highlands (les Hauts du Désert) offre des vues imprenables. Il a été classé en 1990 comme l'un des trois plus beaux au monde.

Das Clubhaus am Desert Highlands Golfplatz bietet eindrucksvolle Aussichten. Im Jahr 1990 stand es an dritter Stelle der schönsten Clubhäuser.

デザート・ハイランドのクラブハウスから素晴らしい景色が眺められる。1990年には3番目に美しいコースとしてランクされた。

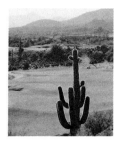

page 106

Tres campos de golf en Desert Mountain (Montaña del Desierto), disenados por Jack Nicklaus, se mezclan con el escenario desértico.

Les trois parcours de Desert Mountain, conçus par le champion Jack Nicklaus, se fondent dans le paysage du désert.

Die drei Golfplätze am Desert Mountain, von Jack Nicklaus entworfen, verbinden sich harmonisch mit der Wüsten-landschaft.

ジャック・ニクラウスの設計によるデザート・マウンテンの3つのゴルフコースは砂漠の景色とうまく溶け込んでいる。

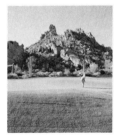

page 107

El pico Pinacle domina la vista del hoyo numero 15 en el campo de golf Desert Highlands (Colinas del Desierto).

Pinnacle Peak surplombe le green du quinzième trou, sur le parcours de Desert Highlands.

Pinnacle Peak beherrscht das 15. Loch am Desert Highlands Golfplatz.

デザート・ハイランド・ゴルフ場の15番グリーンからそそり立つピナクル・ピーク山が圧倒的である。

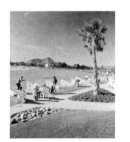

page 108

Unos entusiastas golfistas hacen de la práctica parte de su vida cotidiana.

Les fanatiques de golf ont la possibilité de pratiquer tous les jours.

Golfenthusiasten machen Übung zu einem Teil ihres täglichen Lebens.

ゴルフの練習を生活の一部としている熱心なゴルファー達。

page 109

La sociedad doméstica al osado Oeste.

La société s'efforce d'apaiser les turbulences de l'Ouest traditionnel.

Die Gesellschaft zähmt den Wilden Westen.

現代生活が古い西部時代の荒々しさから危険を忘れさせている。

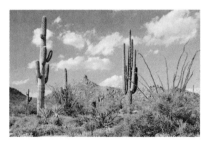

pages 110-111

El desierto en primavera.

Le désert de Sonora au printemps.

Die Wüste im Frühling.

砂漠の春。

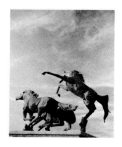

page 112

El grupo en bronce de Snell Johnson en WestWorld captura e illustra el dinamismo de la sociedad de Scottsdale.

Les chevaux de bronze de l'artiste Snell Johnson, installés à l'entrée de WestWorld, symbolisent la vitalité de la communauté de Scottsdale.

Die Bronzegruppe von Snell Johnson an der WestWorld fängt die Dynamik von Scottsdale ein und veranschaulicht sie.

ウエスト・ワールドのスネル・ジョンソンによるブロンズ像がスコッツデールの地域のダイナミックさを象徴している。

Note of the author.

My photographs appearing in this book were made specifically for this purpose, from August 1990, through May 1991. All are original material.

I express my gratitude to the residents of Scottsdale who gave me advice and introductions, welcomed me on their property or accepted to appear in this book. In addition to bringing a personal touch and a community feeling, they all greatly facilitated my work.

I acknowledge the friendliness and professionalism of every one at Grand Canyon Color Lab for the processing of my Kodachromes, and at Subiacolor Professional Lab for a variety of custom jobs.

The equipment I used included three Nikon cameras and a variety of Nikkor lenses. Films were Kodachrome 64 and Kodachrome 200.

Michel F. Sarda

Selected Bibliography

BOOKS

Armstrong, Blair Morton. *Arizona Anthem.*
Scottsdale: Mnemosyne Press, 1982.

Behn, Harry. *Siesta.*
Phoenix: The Golden Bough Press, 1931.

Benton, Patricia. *Signature in Sand.*
New York: Greenberg, 1952.
(Book designed and illustrated by Paul Coze).

Benton, Patricia. *Medallion Southwest.*
Santa Fe: The Rydal Press, 1954.

Benton, Patricia. *Cradle of the Sun.*
New York: Fell, 1956.

Benton, Patricia. *Arizona, The Turquoise Land.*
New York: Fell, 1958

Cawes, Mary Ann. *Saint-John Perse. Selected Poems.*
New York: New Directions Books, 1982

Fuller, Wallace. *Devil's Playground, an anthology: 1850-1950.*
Self-published, 1989.

Grissom, Irene Welch. *Under Desert Skies and Other Verses.*
Caldwell, Idaho: The Caxton Printers, 1956.

Hall, Sharlot. *Cactus and Pine, Songs of the Southwest.*
Phoenix: Arizona Republican Print Shop, 1924.

Hall, Sharlot. *Poems of a Ranch Woman.*
Prescott: Sharlot M. Hall Historical Society of Arizona, 1953.

Lynch, Richard. *Winfield Scott, A Biography of Scottsdale's Founder.*
Scottsdale: City of Scottsdale, 1978.

McFarland, Lois. *Partners in Progress, from Scottsdale, Jewel in the Desert.* First edition. Windsor Publications, 1984.

Major, Mabel, & Pearce, T.M. *Signature of the Sun, Southwestern Verse: 1900-1950.* Albuquerque: University of New Mexico Press, 1950.

Myers, Patricia. *Scottsdale, Jewel in the Desert.*
Windsor Publications, 1958.

Frank Lloyd Wright. *An autobiography.*
New York: Horizon Press, 1977.

NEWSPAPERS AND MAGAZINES

Arizona Highways
Arizona Republic
Phoenix Magazine
Scottsdale Progress
Scottsdale Airpark News
Scottsdale Magazine
Scottsdale Scene

Selected from the *SCOTTSDALE PROGRESS* newspaper files:

Scottsdale Centennial Edition, Friday, July 1, 1988:
Herbert R. Drinkwater. *Living in city is reason enough to celebrate.*
William Jenkins. *Winfield Scott was city's original developer.*
Mary K. Reinhart. *Scottsdale was almost always a boom town*
Arthur D. Nelson & Linda Brock-Nelson, Paul Messinger, Fritz Scholder, Donald Frye, Sam Campana, etc. *Scottsdale Memories: from cows to diamonds.*
Chris Coppola. *Government changed to meet growing city's needs.*
Diane Enos. *Life for Indians changed as white men moved in.*
Charles Montooth. *City's growth featured more ups and downs.*
Editors. *Events shape Scottsdale (chronology, 1881-1983)*
Lois McFarland. *Businesses in early Scottsdale prospered quickly.*
Editors. *Early milestones (selective chronology).*
Editors. *A look back in history (tributes).*
Thelma Holveck. *Early residents recall their small, dusty town.*
Labeula Steiner Mowry. *Scottsdale memories.*
Bill Kimsey. *A boy's life in Scottsdale.*
Melanie Johnston. *City's early development was a study in contrasts.*
Paul Soderberg. *Scottsdale's constant: its quality of life.*
Editors. *Taliesin: Wright's legacy*
Kathy Shoket. *Scottsdale blossomed as art center.*
Stephen Higgins. *Early Scottsdale resorts put it on snowbird map.*
Editors. *A look at tomorrow. Scottsdale's second century.*
Chris Coppola. *Growth, water management provide keys to city's future.*
Stephen Higgins. *Staggering growth places city among nation's top 20.*
Paul Soderberg. *Soleri: Hope for life in a gilded catastrophe.*

A Day in the Life of Scottsdale (pictorial), Friday, April 28, 1989

Scottsdale: A Community Profile, Wednesday, April 18, 1990
Mike Phillips. *Neighborhoods face challenge of change.*
Editors. *Facts about Scottsdale.*
Paul Soderberg. *People make the difference in Scottsdale's profile.*
Kirsty Scott. *Scottsdale citizens have voice in neighborhoods' future.*
Lois McFarland. *Preserving Scottsdale's history.*
Lois McFarland. *Pioneers never lost sight of dreams.*
Sherry Arpalo. *Amenities attract homebuyers.*
Kirsty Scott. *Master-planned areas can click like clockwork.*
Steve Brennan. *Schools are the ties binding city together.*
Linda Coulson. *Airpark to be core of new growth corridor.*
Dave Thomas. *City park system offers recreation for thousands.*
Editors. *Resorts help Scottsdale grab place in the sun.*
Linda Coulson. *Scottsdale becomes key tourist destination in U.S.*
M. Cecline Blaine. *Horses helped make Scottsdale.*
Editors. *Golf changes the image of Arizona.*
Dixie Leggler. *Wright considered 'shining brow' his second home.*
Jason Grant. *Art community has flourished over the years.*
Mike Phillips. *Development weighed against quality of life.*

Scottsdale Newcomers Guide (special supplement, Fall 1990)
Editors. *Who's who and what's what at City Hall – Facts and figures*
History - Demographics - Elevation - Major Industries
Major Attractions - Sporting Events – Recreation - Sightseeing
Major Events – Paradise Valley, Arizona's Beverly Hills
Great dates for city (chronology 1881-1990)

Bill Kimsey. *Recollections of Early Scottsdale, "the way it was."*
Scottsdale Progress, 1987.

Index

Contributing Photographers

Brad Armstrong

Brad, a staff photographer for the *Scottsdale Progress* newspaper, won 10 awards for excellence from the Associated Press and the Arizona Press Club in 1990. His education is in Photography and Journalism from Phoenix Community College and Northern Arizona University.

Brad's professional photographic interests are in editorial, commercial, fashion and stock photography.

Alan Benoit

A Tempe, Arizona, based photographer Alan has published work in over 11 countries and 200 books and periodicals. Major corporations located in Arizona and throughout the United States have utilized his work to illustrate their interests in various regions.

A strong love for the outdoors and natural subjects, combined with an intense curiosity for the way the people of the world live, work, and play have led Benoit's work to be displayed in places as varied as the Nikon House Gallery in New York, the Sonoran Desert Museum in Tucson, and as part of the Alliance Française exhibit in Grenoble, France.

Michael Gene Mertz

Michael is an award winning photojournalist. He is currently the chief photographer at the *Scottsdale Progress*. His work can often be seen in Phoenix and Times Magazines. Past employers include the Associated Press, Parade Magazine and the International Center of Photography.

J. Peter Mortimer

Peter is a contributing editor and the former picture editor of *Arizona Highways Magazine*. He has recently served *Arizona Highways* as a book editor and book designer. As an award winning photographer his client list ranges from Eastman Kodak to National Geographic. He is affiliated with Gamma-Liaison World Press Agency in New York and Paris.

Peter has a Bachelors Degree with post graduate studies in journalism and tele-communications, and has supervised and taught the photo-journalism curriculum at Arizona State University. Additionally, since 1977 he has been Director of Photography at the Summer Media Workshop at the School of Journalism, University of Missouri.

Sonny Ness

" I was born and raised on a farm near Mitchell, South Dakota, and graduated from Mitchell High School in 1942. A combat medic with the 97th Division in Europe from 1943 until VE Day, I then went to Japan for occupation duty. There, I traded packs of military-issue cigarettes for my first good camera. Most of my working life was in the tree care business. It's been a hobby ever since, and I became Arizona's first International Society of Arboriculture certified arborist in 1985. I retired as Scottsdale Urban Forester in 1989. I currently play with trees, cameras, and wood, and also work on carving a sculpture carved out of a dead tree at Scottsdale's main library."

Bill Timmerman

" I've always been interested in making images and you might think a camera is a fairly easy way to make appealing images. But the more photography you do, the more you realize, like in any other medium, that the making of expressive images requires an almost consuming interest. An interest not only in the combination of techniques available to you photographically, but most importantly, what it is you choose to make an image of. You must first understand or feel what your shooting is about, and then attempt to do so – that's when photography becomes exciting. Photography invariably takes me, mentally and physically, to places that I might have never seen or felt."